TO JOHN & DORIS

MERRY CHRISTMAS 2010

Alberta
IMAGES *by* DARYL BENSON

NOV 2010

CHRISTMAS 2010
FROM: DOUGLAS YOLANDA.
TIA. LUCAS

Alberta — Images by Daryl Benson
Copyright ©2004 Daryl Benson
www.darylbenson.com

Published by Cullor Books

Printed in China

10 9 8 7 6 5 4

Editor: Gary Whyte
Design: Peter Handley RGD, www.phdcreative.com

Limited Edition signed prints are available through:
 Time Frame
 9520 Ellerslie Road
 Edmonton, Alberta, Canada
 T6X 1A7

 780-463-1422

Library and Archives Canada Cataloguing in Publication

Benson, Daryl
 Alberta: images / by Daryl Benson.

ISBN 0-9684576-2-2 (bound)
ISBN 0-9684576-3-0 (casebound)

 1. Alberta–Pictorial works. I. Title.

FC3662.B45 2004 971.23'0022'2 C2004-902909-6

Dedication

This book is dedicated to the bravest person I have ever known—
my mother, *Marge Benson (1937–1991)*

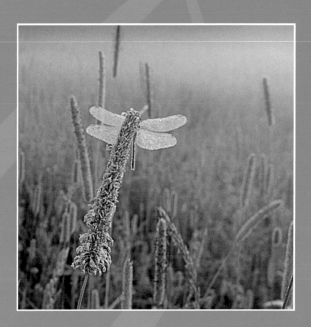

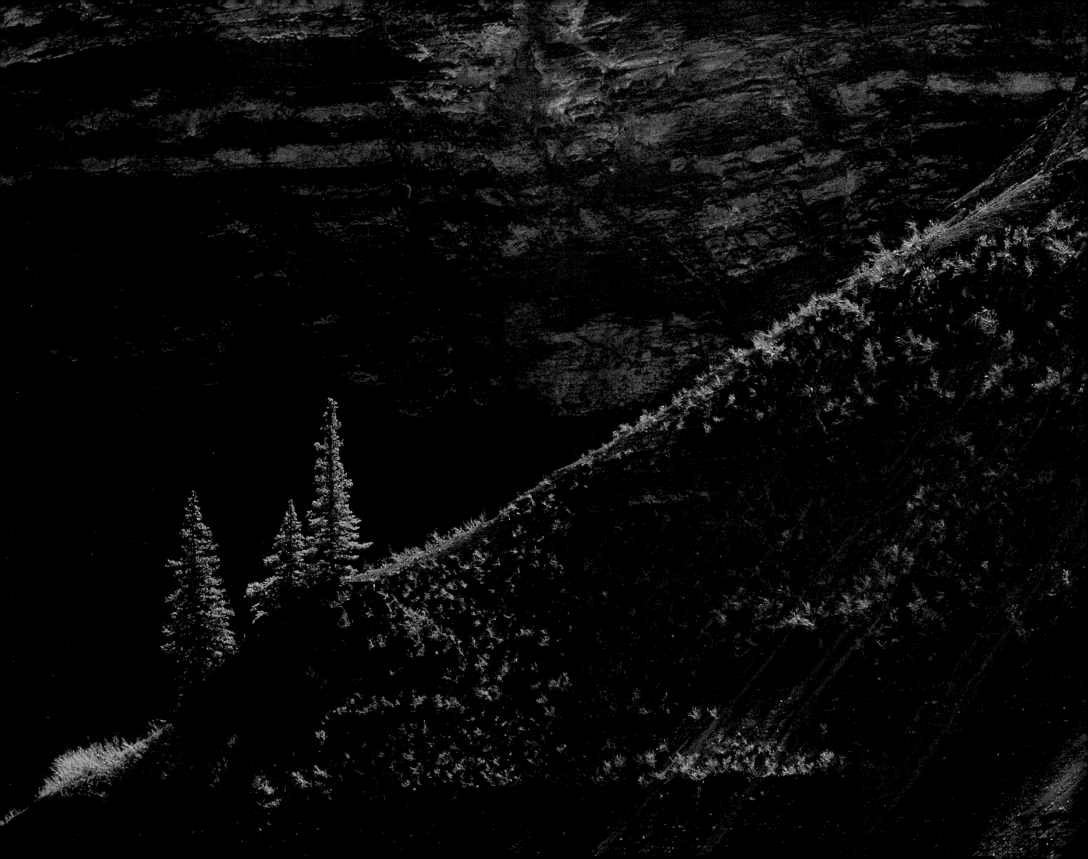

Introduction

I was born and raised in Alberta, with the wide-open prairie stretching far toward the east and the peaks of the Canadian Rockies looming large in the west. I grew up watching winter snows dust those mountain peaks, summer thunderstorms rumble across the prairies, early morning fog float through the coulees, and northern lights dance in the clear night skies.

I've enjoyed a career spanning almost 20 years travelling and photographing this province, this country and the globe. I know I'm biased, but I think Alberta is the most beautiful place on earth, especially for a photographer.

◄ SHEEP RIVER GORGE, KANANASKIS COUNTRY

Spring

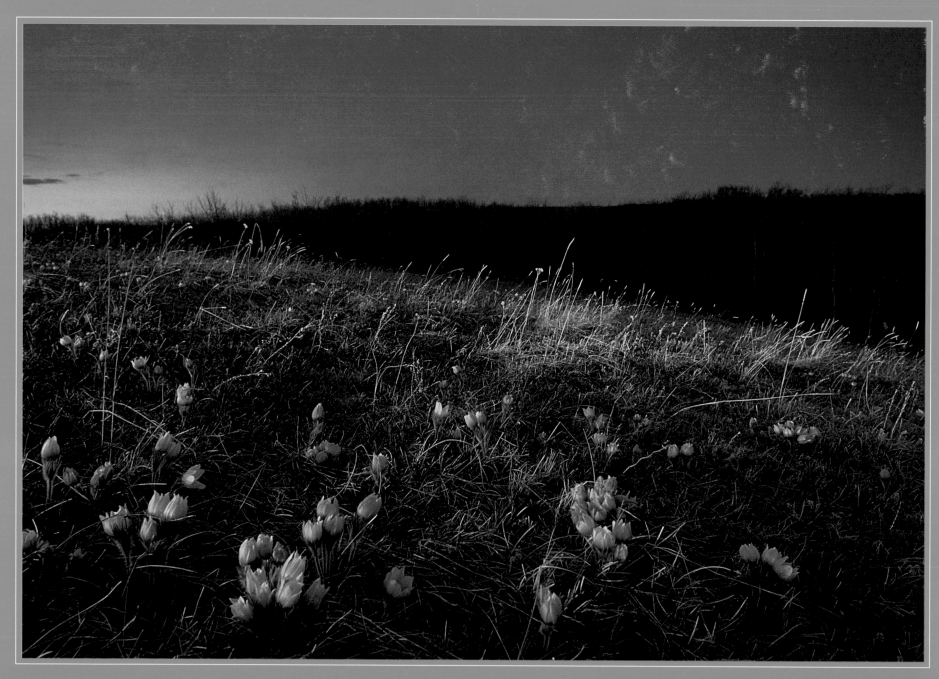

WILD CROCUSES, NEAR DELBURNE

It's Home

I hold the bragging rights to setting foot on and photographing on all seven continents. From penguin colonies surrounded by glaciers in Antarctica to aromatic fields of lavender in Provence, France; from the dragon's teeth limestone mountains of Guilin, China to the arid, red Nullarbor Plain of the Australian outback; and from the wind-tortured mountains of Patagonia in South America to mass wildlife migrations on the Serengeti Plain of Africa— I've seen and photographed all these things and so many more. However, I capture my best photographs in the meadows, mountains and coulees of Alberta. Here, I know from which direction the winds and the summer thunderstorms come; I know where and when the spring wildflowers bloom; I know which mountain ponds are lee side to the wind and cast the calmest reflections; and I know where to be at harvest time when the dust and chaff turns the sunsets gold. I know all these things and more because this is the place I know best—*it's home!*

Alberta

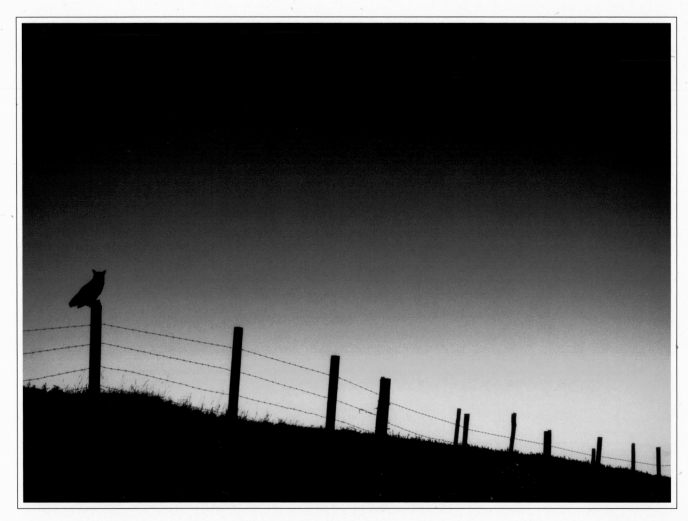

GREAT HORNED OWL (PROVINCIAL BIRD), NEAR ELK ISLAND NATIONAL PARK

Alberta

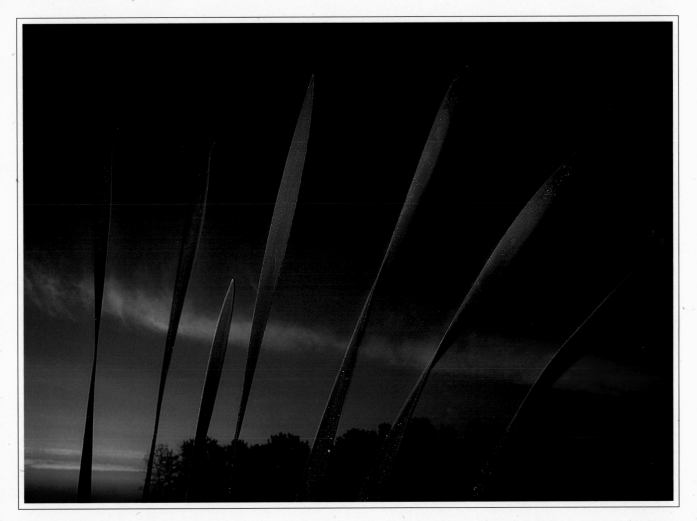

CATTAIL REEDS, DAWN, NEAR EDMONTON

Alberta

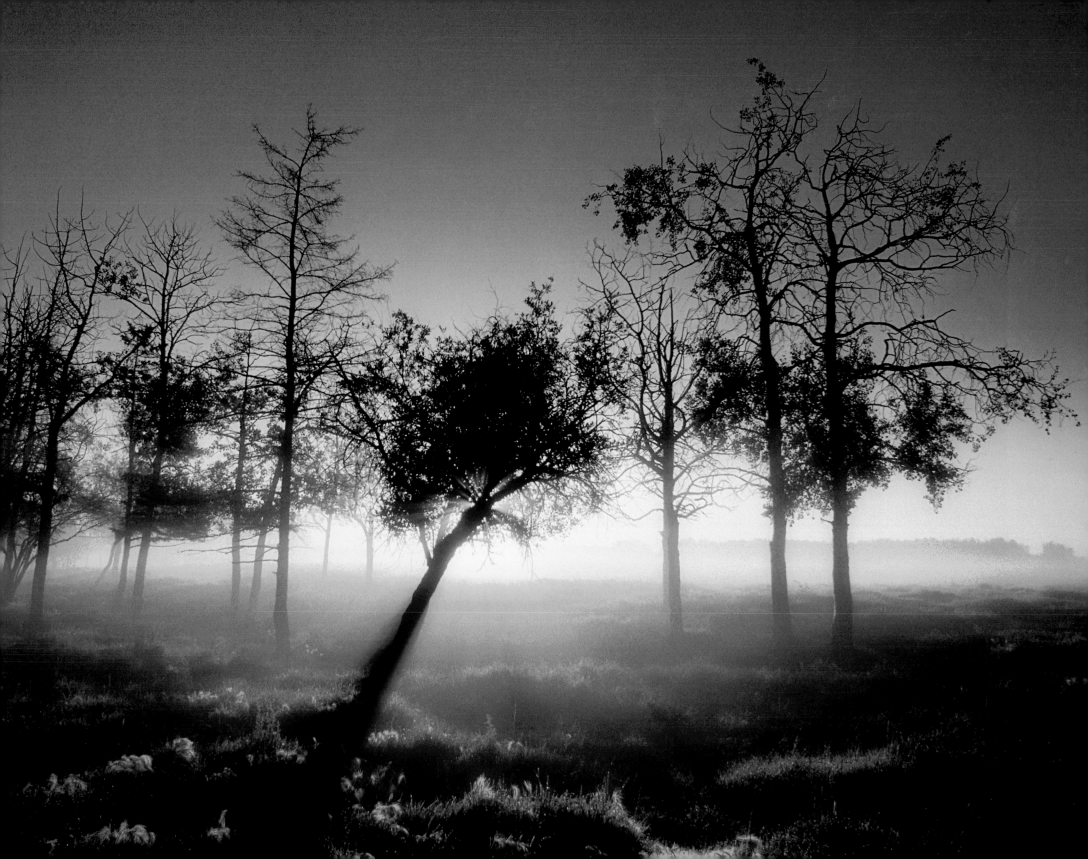

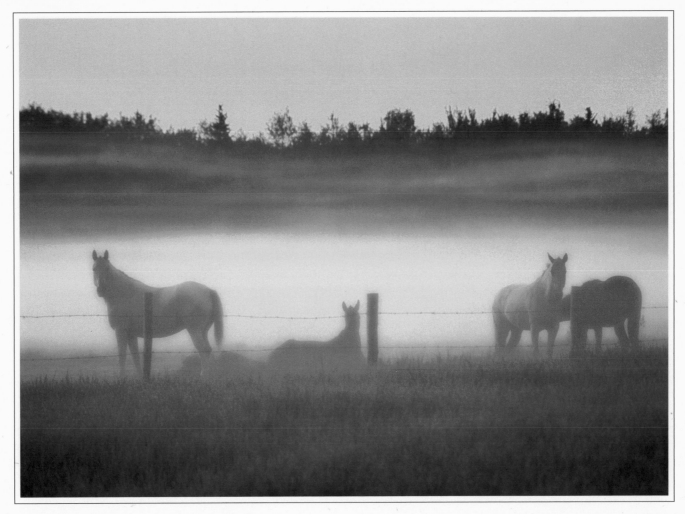

HORSES IN MORNING FOG, NEAR HAY LAKES

◄ SUNRISE, NEAR SLAVE LAKE

Alberta

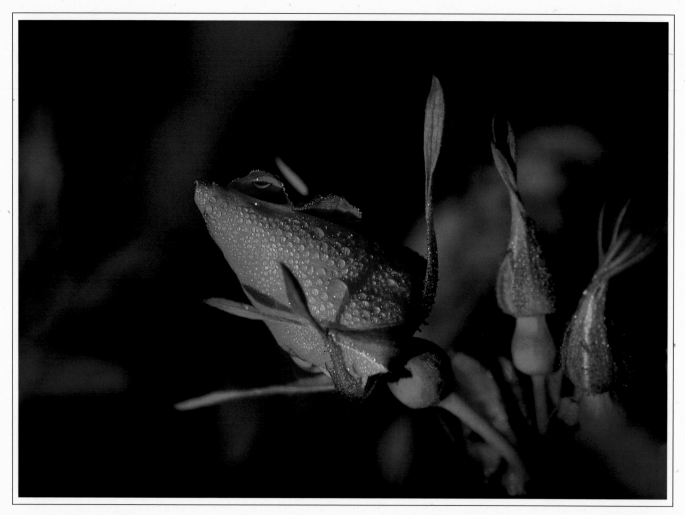

ALBERTA WILD ROSE

ASPEN TRUNKS AFTER SPRING SHOWER, JASPER NATIONAL PARK ➤

Alberta

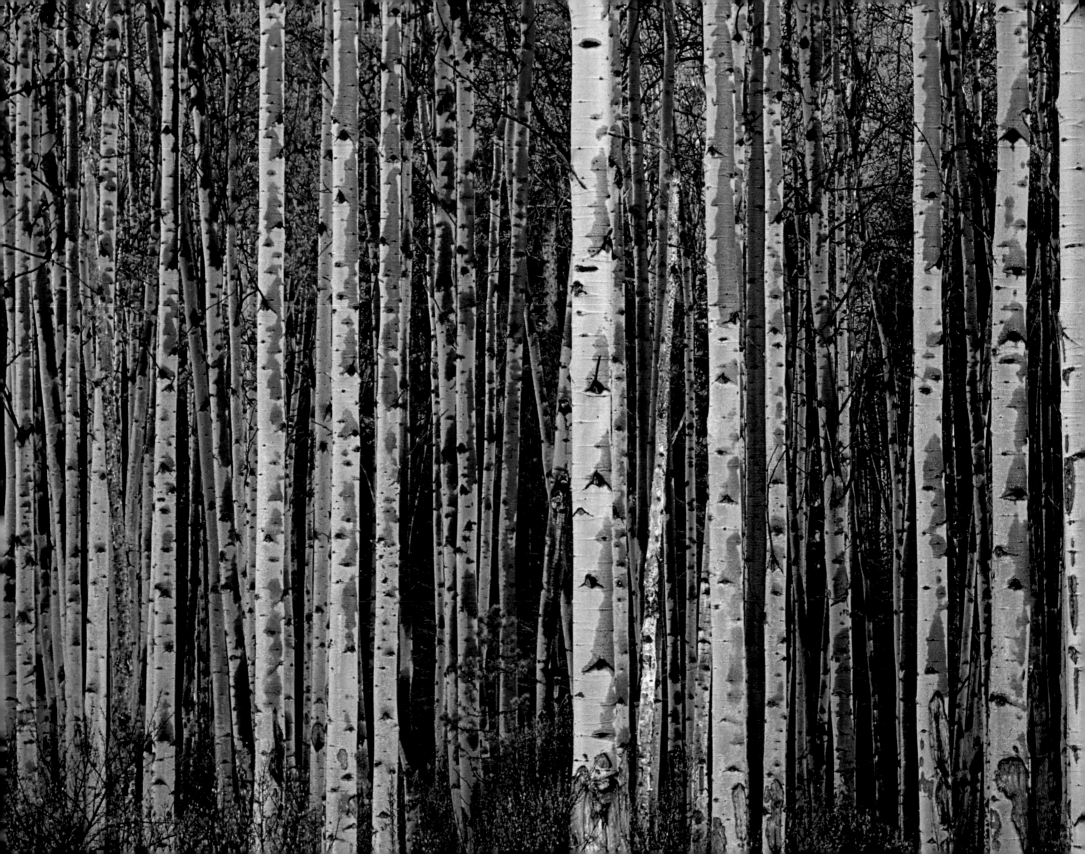

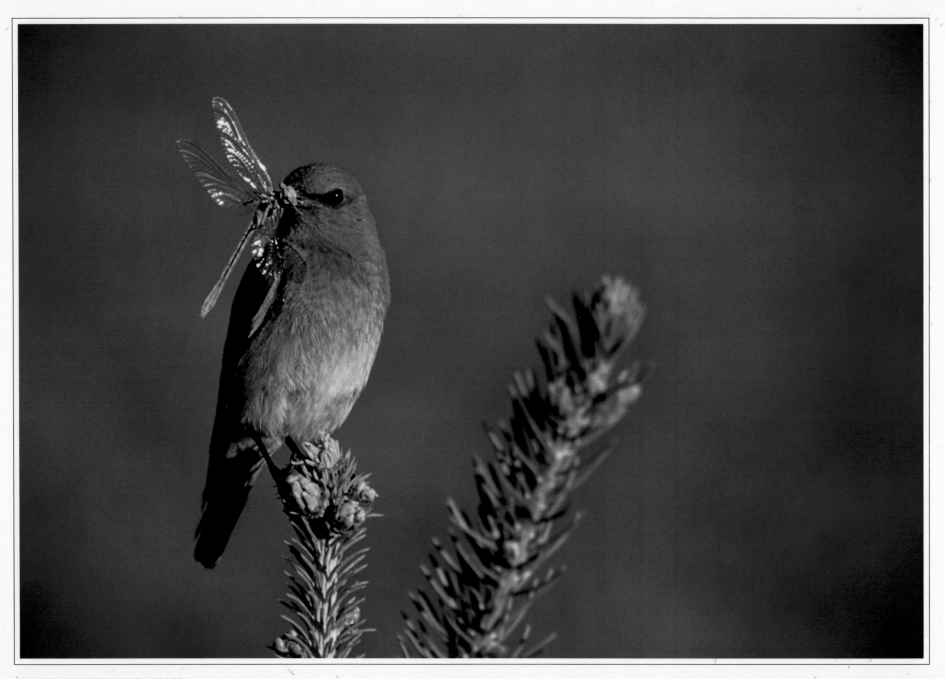

BLUEBIRD WITH BREAKFAST

Alberta

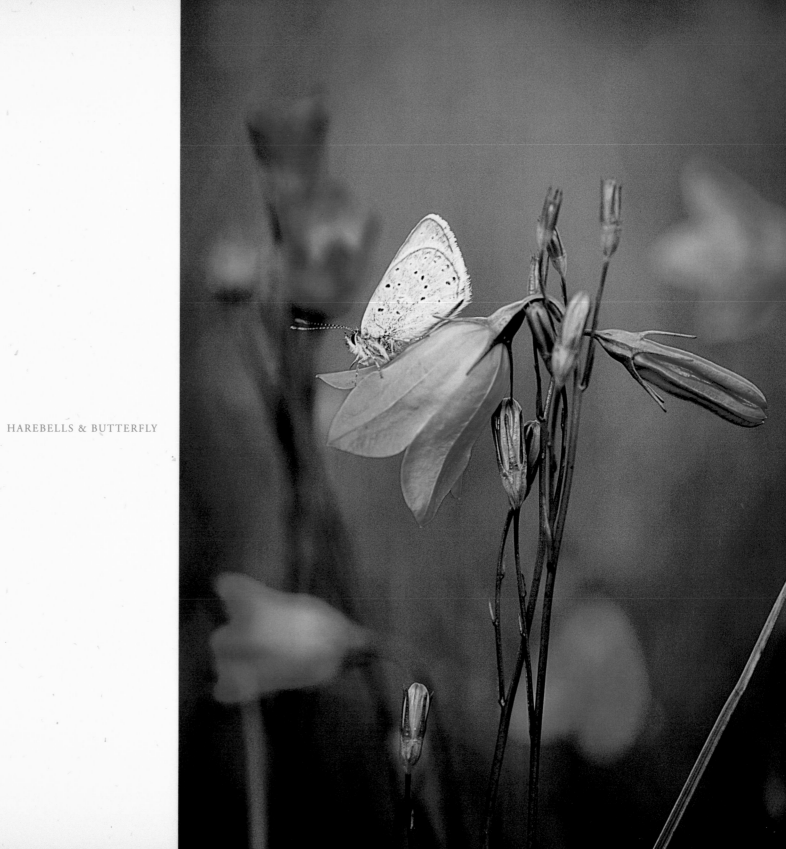

HAREBELLS & BUTTERFLY

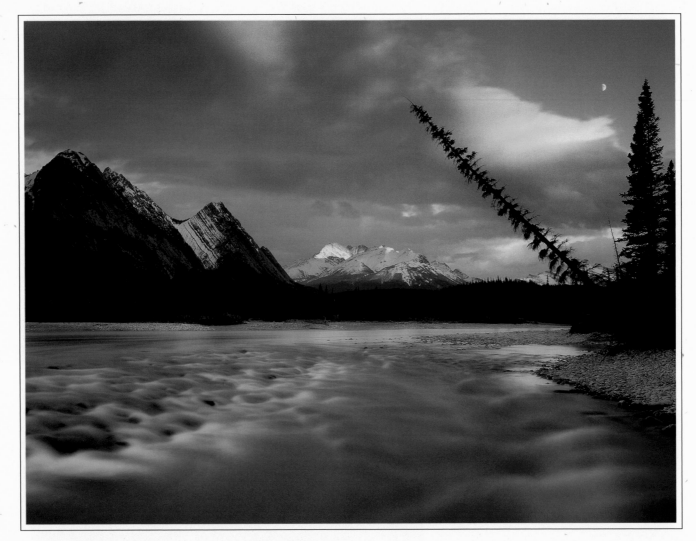

DUSK, NORTH SASKATCHEWAN RIVER, KOOTENAY PLAINS

SUNRISE, BOW LAKE, BANFF NATIONAL PARK ➤

Alberta

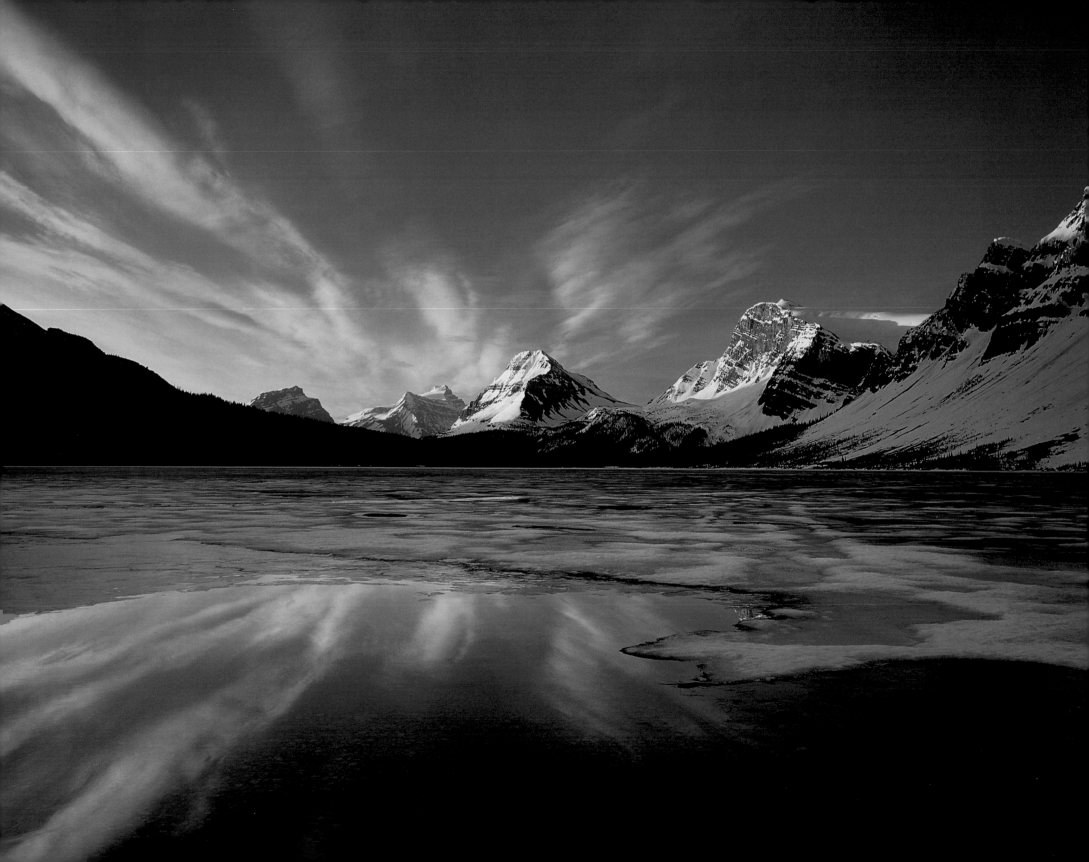

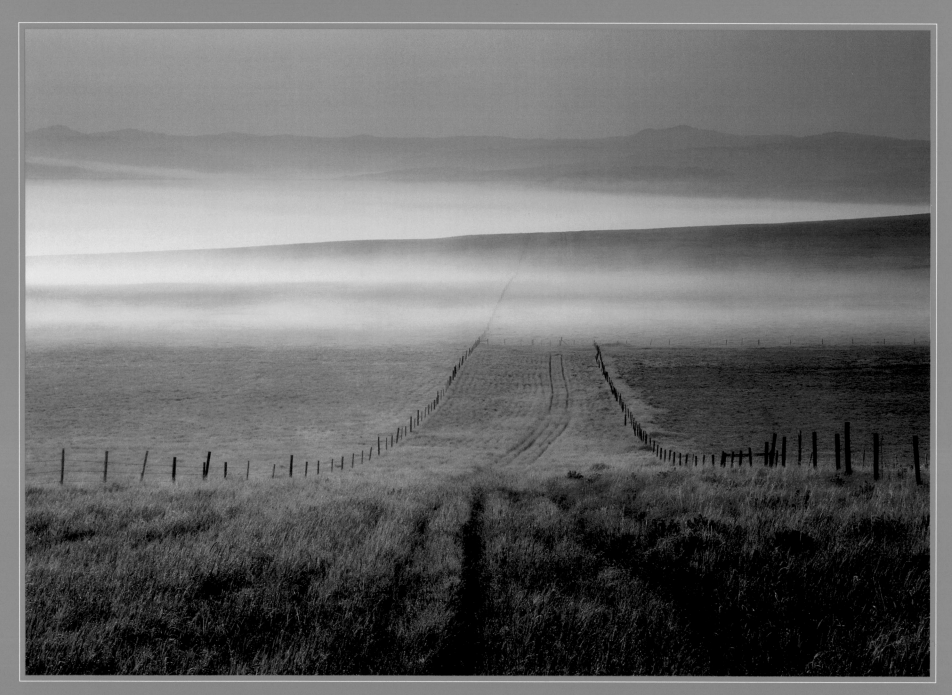

DAWN, PORCUPINE HILLS, SOUTHERN ALBERTA

FROST ON FURROWS, SUNRISE, NEAR SHERWOOD PARK ➤

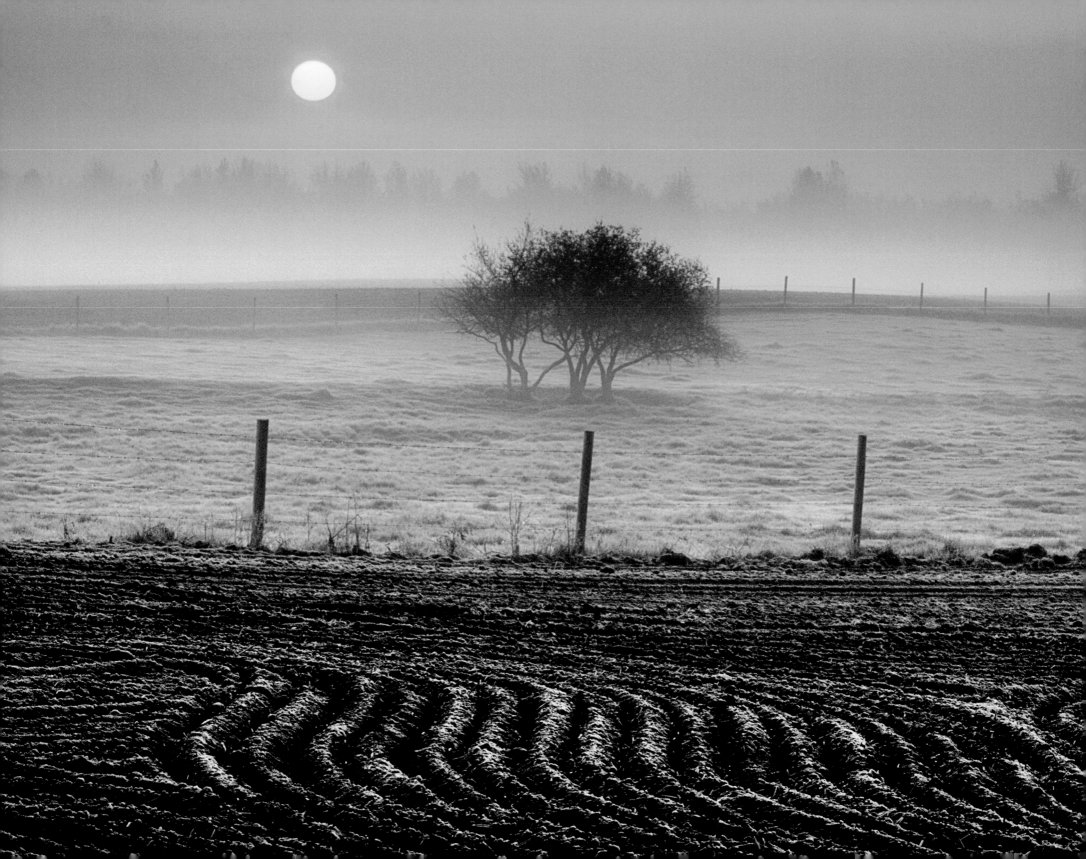

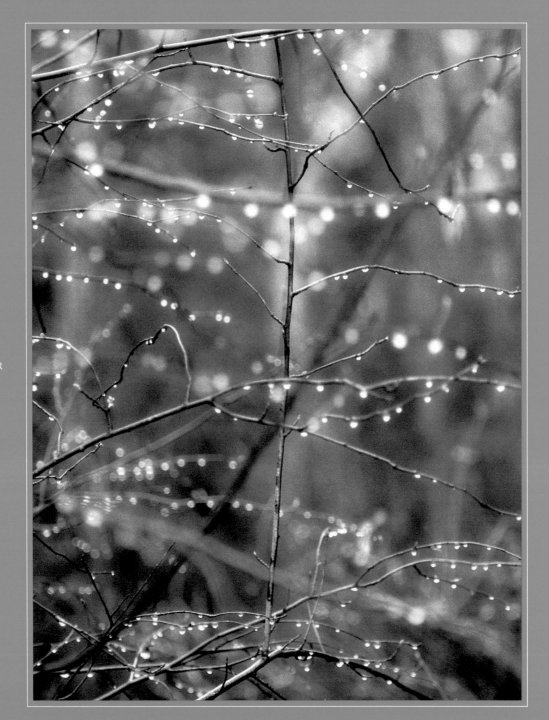

SPRING RAIN, NEAR RED DEER

POPLARS AT DUSK, ➤
ILLUMINATED BY AN
OIL FIELD GAS FLARE

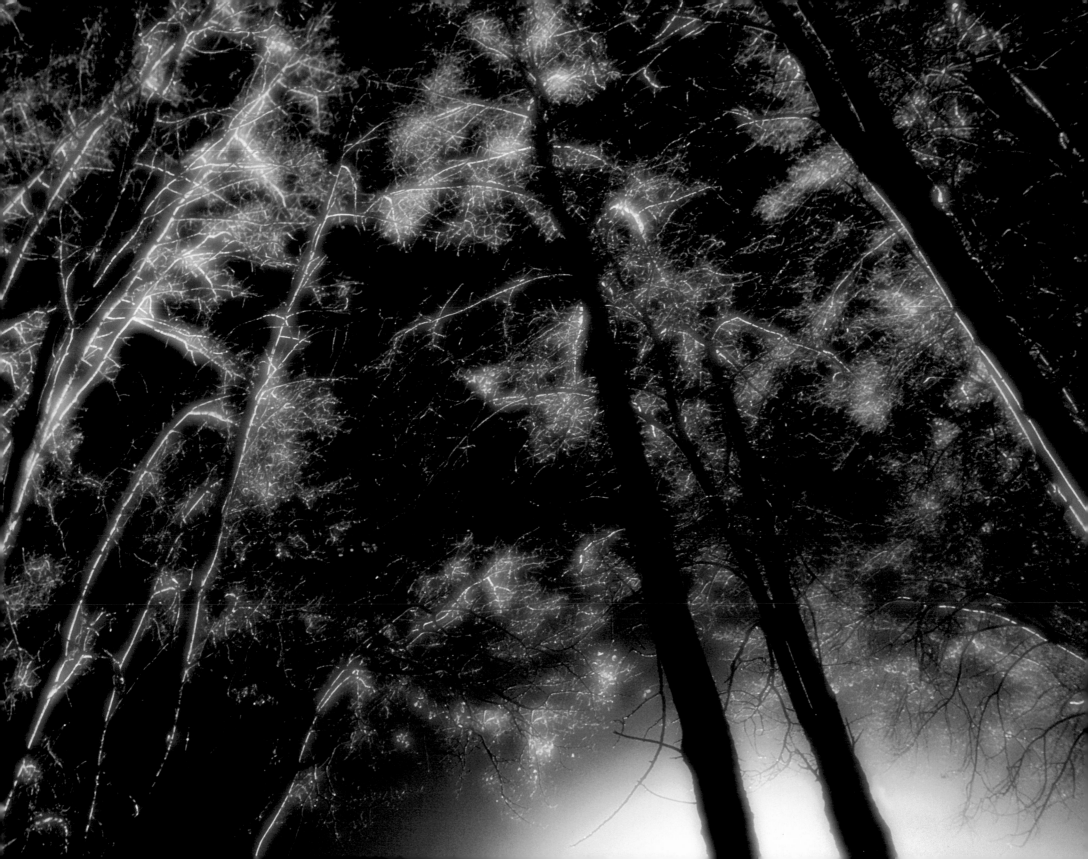

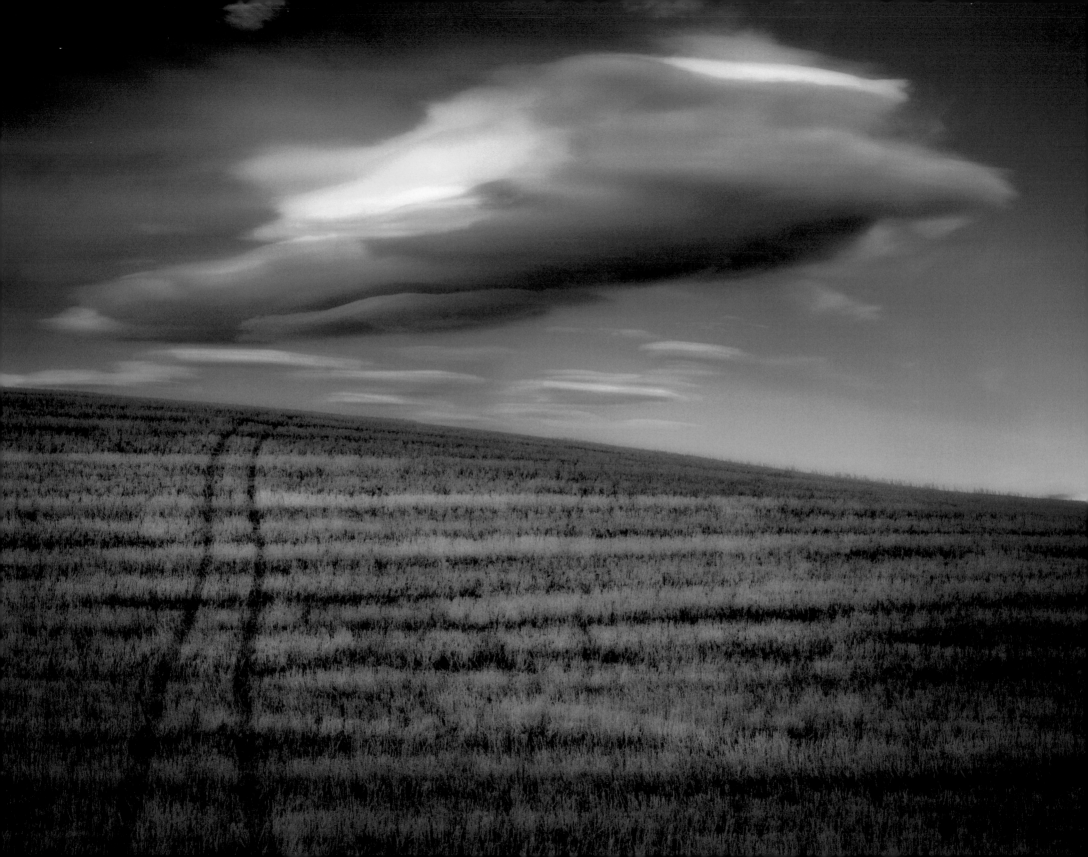

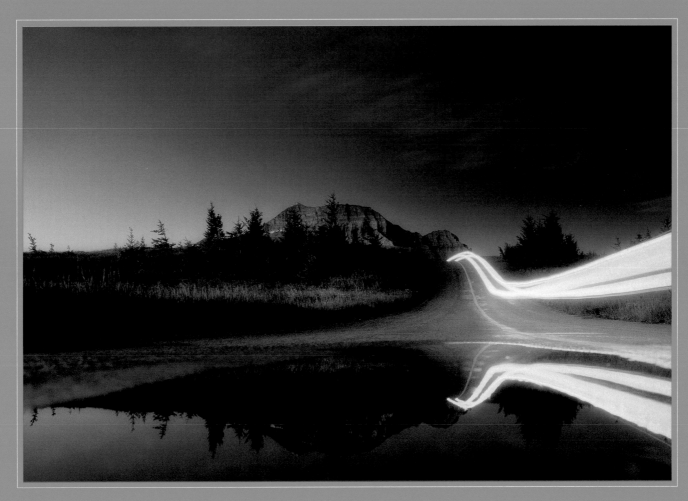

TAILLIGHTS REFLECTED IN PUDDLE, WATERTON LAKES NATIONAL PARK

◄ LENTICULAR CLOUDS, NEAR PINCHER CREEK

Cows

It's tough to escape the gravitational pull of a nice warm bed at 3:00 AM, but if you can, the late spring, dew-laden, dawn landscapes of rural Alberta are yours. This is my absolute favourite time to photograph. It's as if, for a few hours, the whole world is yours alone. Fog often hangs over the sloughs and low-lying areas, while dew glazes the prairie grasses, wildflowers, dragonflies, and spiderwebs.

I can remember driving the rural range roads near the edge of town early one spring morning and having my attention drawn to an entire field of dew-draped spiderwebs glistening in the morning light. I pulled over, grabbed my camera bag and tripod, jumped the three-strand barbed wire fence, and trotted off to do some macro photography. There was a small group of cattle in the field, but they were of no concern to me.

I have been around cattle almost all my life and their usual reaction is to run away for a few metres, stop, exhausted by the slight exertion, and then stare at you curiously for a few minutes before going back to chewing cud.

I was stretched right out on the ground in the middle of that field doing some close-up, wet-belly photography. I could hear the cows as they slowly came closer and started to sniff and snort, but again they were of little concern to me as I was really absorbed with capturing the macro images of the dew-laden spiderwebs. Finally, their licking noises and close proximity got my attention, so I turned my head to see what the commotion was all about. In my haste I had left the camera bag open on the ground a few feet behind me. The cows had gathered around, licking,

slobbering, snorting, and just generally depositing cattle-sized ribbons of mucus all over the inside of the exposed bag and on my lenses, film, and camera gadgets inside. Everything in that bag was covered in a layer of slime that goes well beyond my command of English to describe. It was pretty much the most disgusting mess that I've ever had to clean up.

Cows! Don't trust 'em, and don't turn your back on 'em. I think they have some fuzzy understanding of their fate and, given the opportunity, are more than willing to exact a wee bit of revenge. I don't believe Alberta cattle are madder than cattle anywhere else, but I do think they are a bit shrewder and a lot more devious. It comes with the territory.

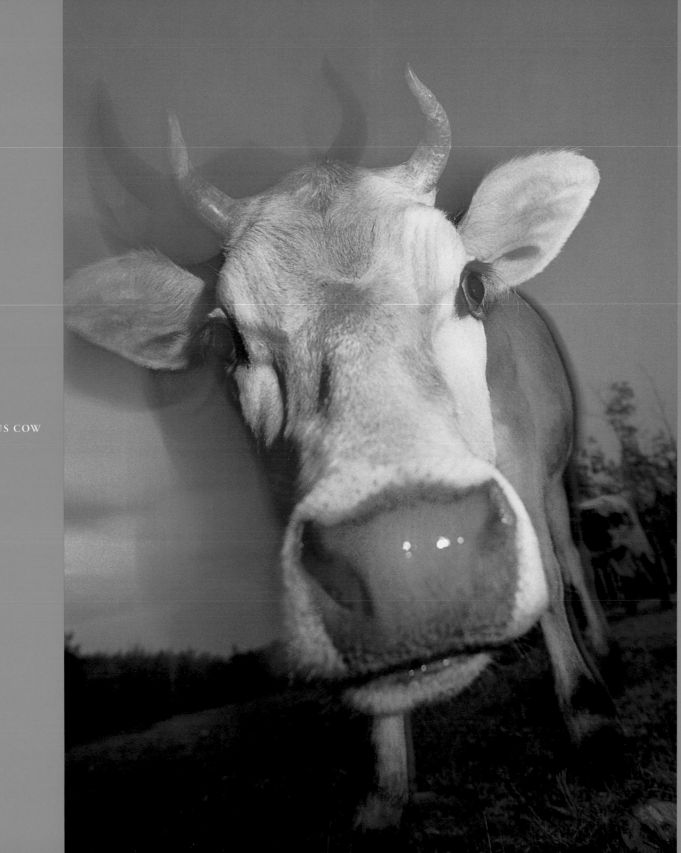

CURIOUS COW

Summer

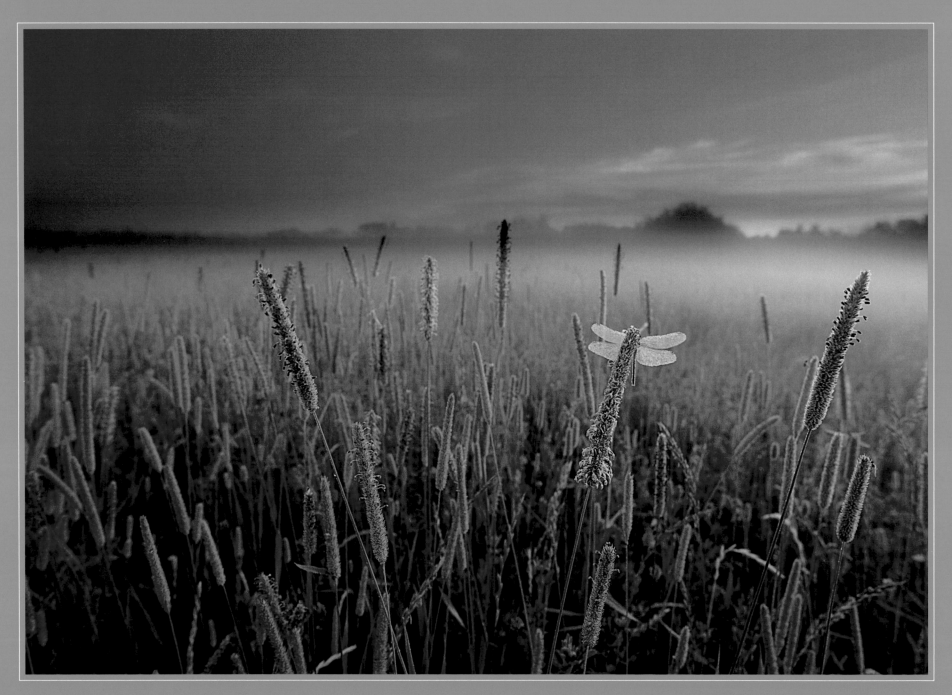

DEW-COVERED DRAGONFLY AT DAWN, NEAR SHERWOOD PARK

the Creature

A very large dragonfly landed on the wood fence in our backyard. My young daughter was startled by its size and the unexpected rustling sound its wings made as it occasionally launched itself into the yard, patrolling for mosquitoes. She watched its movements with both curiosity and trepidation. The dragonfly was harmless of course, but I think its large size, especially when viewed through her young eyes, seemed intimidating. In her mind she probably imagined it would sting her, or worse, carry her off to feed its young. I tried to reassure her by suggesting that if she left it alone it would just go about its business. Without lifting her stare from the creature, she nervously asked, *"Daddy, what is its business?"*

Alberta

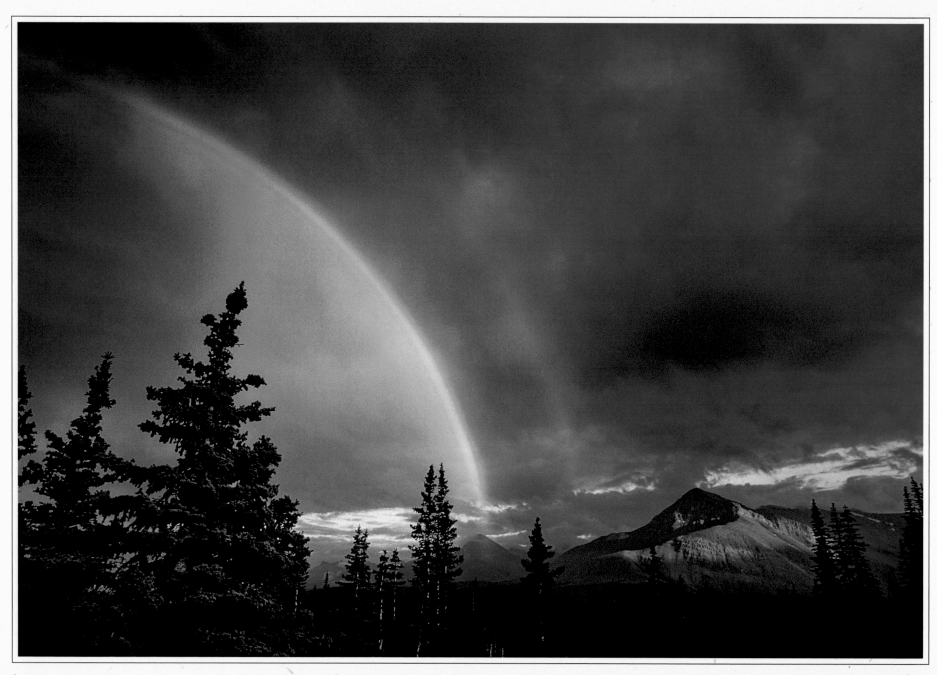

NEAR CADOMIN

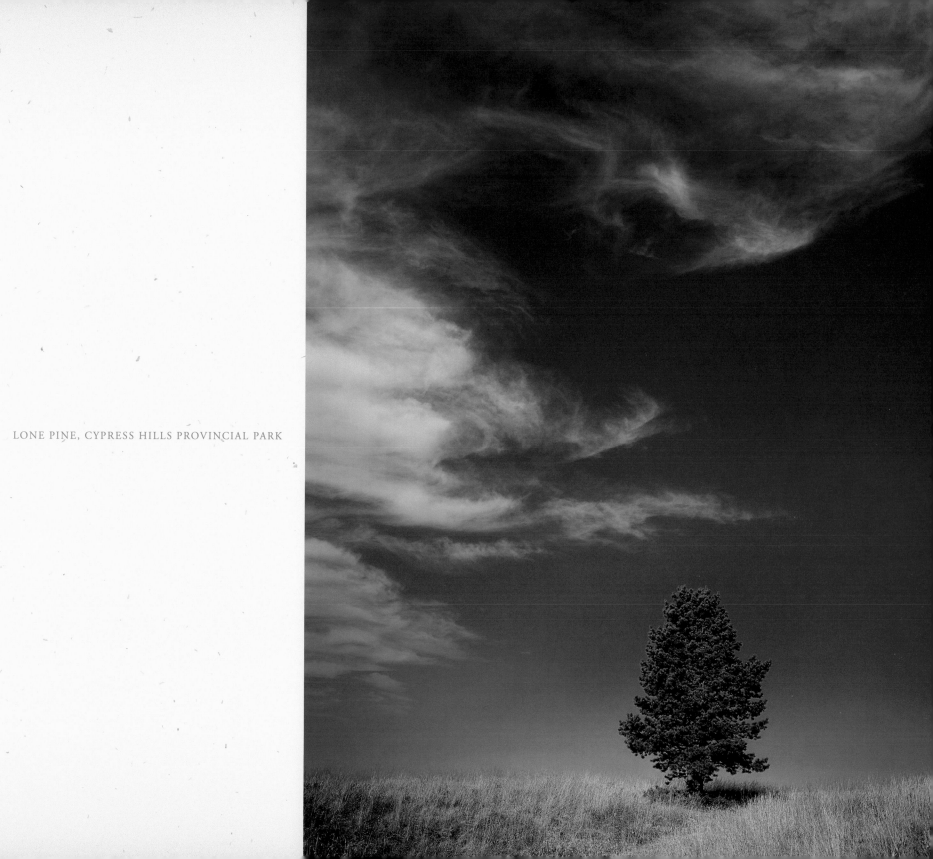

LONE PINE, CYPRESS HILLS PROVINCIAL PARK

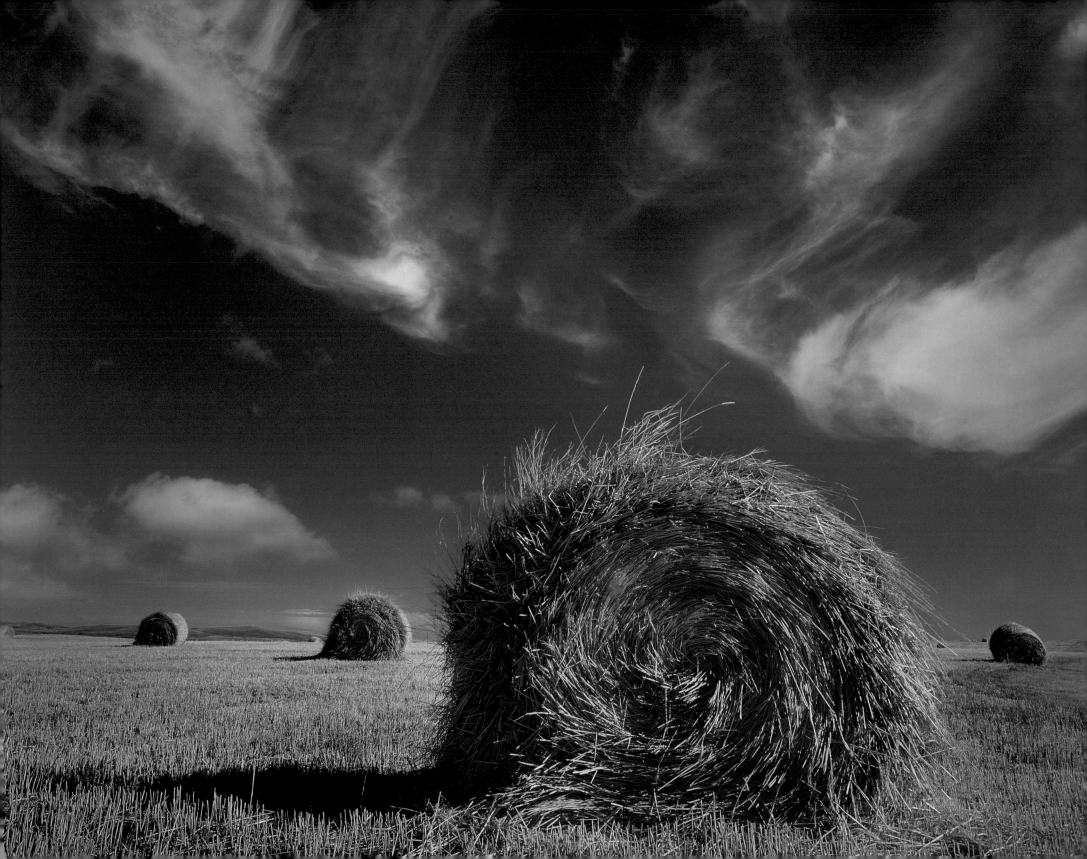

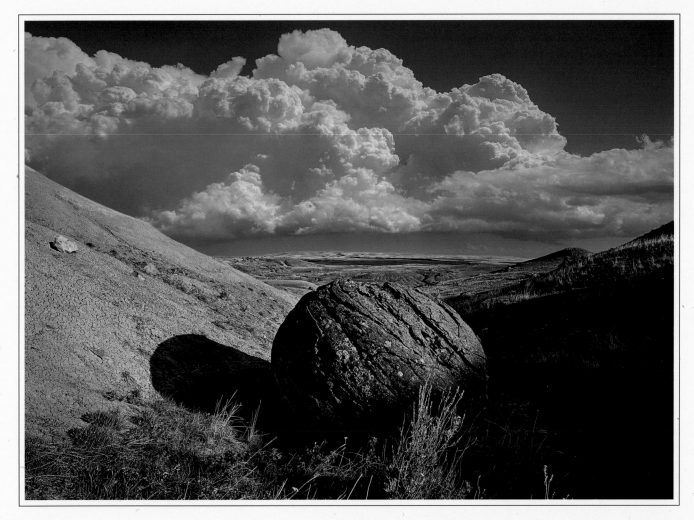

RED ROCK COULEE NATURAL AREA, NEAR SEVEN PERSONS

◄ BALES AND CIRRUS CLOUDS, SOUTHERN ALBERTA

Alberta

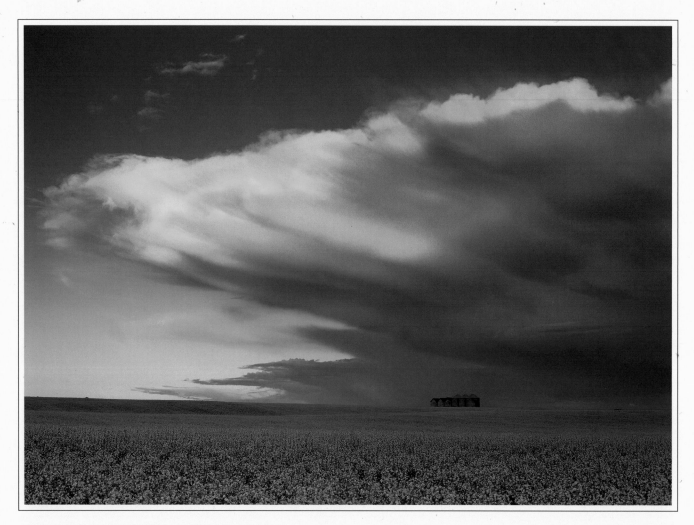

PASSING SUMMER STORM, NEAR EDMONTON

Alberta

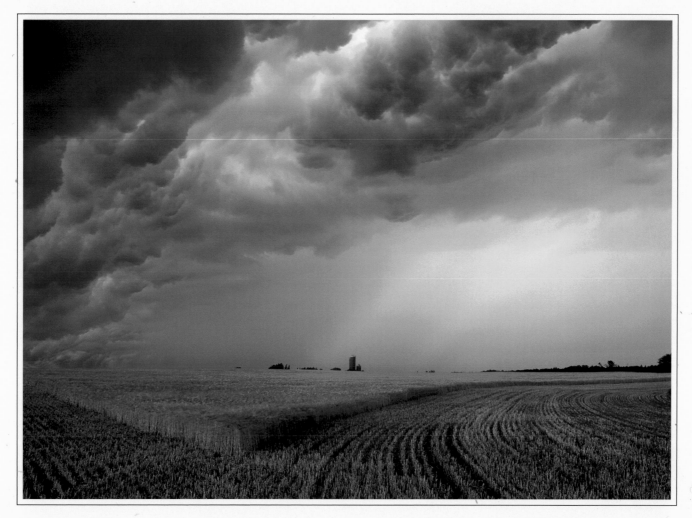

PASSING SUMMER STORM, NEAR CALGARY

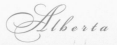

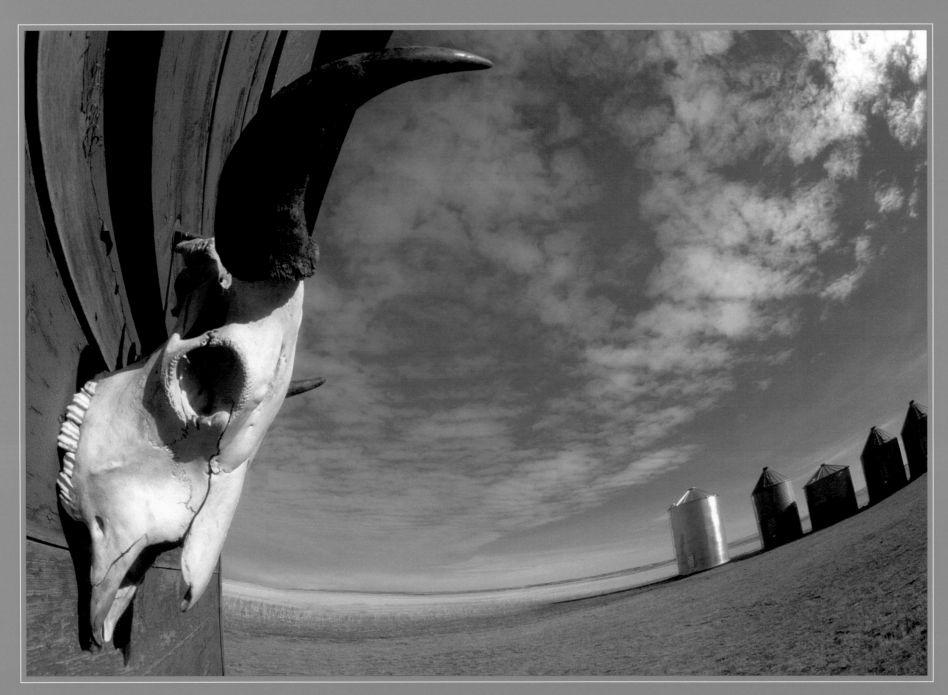

BISON SKULL ON GRANARY, NEAR MEDICINE HAT

the Old Pump

When it finally glugged and spurted out of the faucet and into the glass, it was an extremely cold, bubbling, hissing elixir that, upon consumption, would simultaneously quench your thirst, make you belch and give you a numbingly painful brain freeze. We drank this farm well water because a) it was the only option we had, and b) despite its presentation, it could quench any dry, dusty, prairie-sized thirst you might bring to it.

When I was in high school I used to spend a good percentage of my summers working on my grandfather's farm. The old pump that coaxed that bubbling well water from the aquifer caved on us at least once a month. My uncle and I would go out to the garage, where he'd grab the bucket of spare seals, oil, and bolts, and then climb down into the narrow pit that housed the pump. I'd stand at the top, listen to him swear in Italian for half an hour, and the pump would be fixed. One day, however, was different. After the usual period of cussing at the thing, my uncle tossed me a rope and told me to pull up on it as hard as I could. I put on my gloves, wrapped the thick, braided rope around each hand,

and planted my feet, shoulder-width apart, on the hard cement floor at the edge of the pit. I bent my knees in a semi-crouch, leaning back slightly, and with spine straight, arms fully extended, and shoulders square, I began to pull. The main shaft of the pump, which is what my uncle wanted removed, didn't budge. *"Pull, Daryl! Pull!"* he yelled. I pulled. I pulled with a strong, steadily increasing force, and as I pulled, I could sense the rope tighten sharply and begin to bite through the gloves into my hands. I was aware of the sensation but it didn't register as pain. It was just kind of there. Pain, I'm guessing, would have gotten in the way of pulling on that rope and for some reason that I still don't understand, my body and mind had, on their own initiative, entered into a battle with that rope and pump. Every fibre of my body was slowly coming into line as a whole, with every part of my being focused on pulling that rope. *"Pull, Daryl! Pull!"* my uncle yelled up again. I could hear him, like a faraway voice, but I didn't try to respond. The simple act of answering was not possible, as it would have taken breath and energy

that I wasn't willing to spare from the still-mounting energy that was increasingly focused on the task.

Then it began. I could feel it. On an almost microscopic level, the old pump's resistance was beginning to give way to me. Bit by tiny bit I could feel it slowly letting go while my own strength continued to grow. My stamina seemed boundless—I felt as if I could exert my will with limitless strength and endurance! Suddenly, *"Stop! Stop! Wait a minute,"* my uncle yelled. In less than a second, in what felt like a slow, controlled, system-wide shutdown, I eased my tension on the rope. I heard my uncle's wrench banging the old pump shaft for a moment, I heard some more Italian being spoken, and then he said, *"I missed a couple of bolts."* Laughingly he handed the now twisted pieces of metal up to me. I remember holding them in the palm of my hand and thinking with absolute certainty that, had he left me to the task a few seconds longer, I would have sheared those two bastard bolts in half.

I've never felt as strong as I did that summer.

Alberta

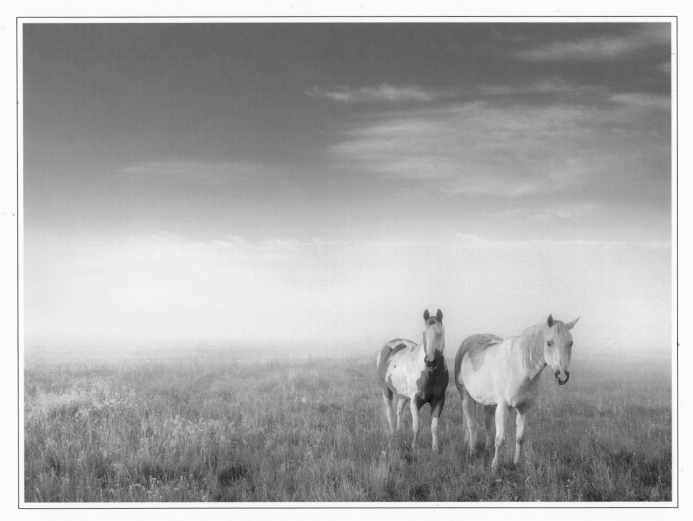

HORSES IN FOG, CENTRAL ALBERTA

DAWN, MILK RIVER CANYON, SOUTHERN ALBERTA ➤

Alberta

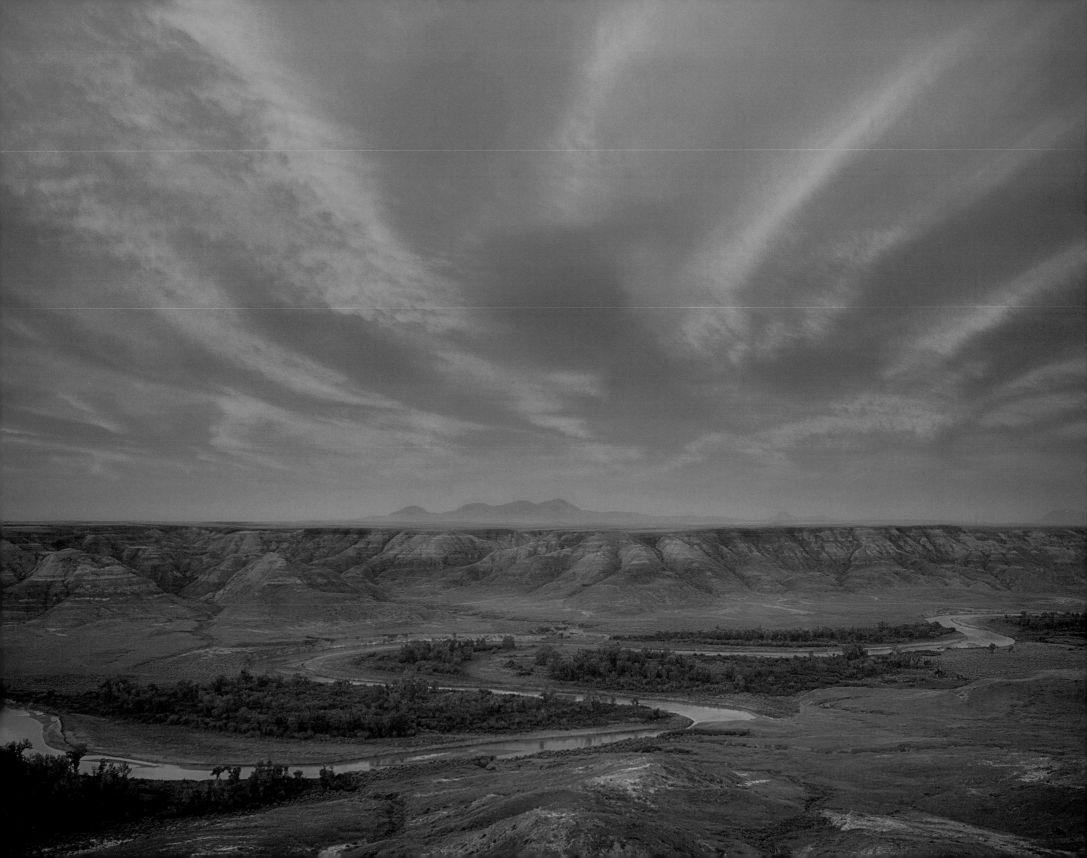

SUNRISE, SPIRIT ISLAND, MALIGNE LAKE, JASPER NATIONAL PARK

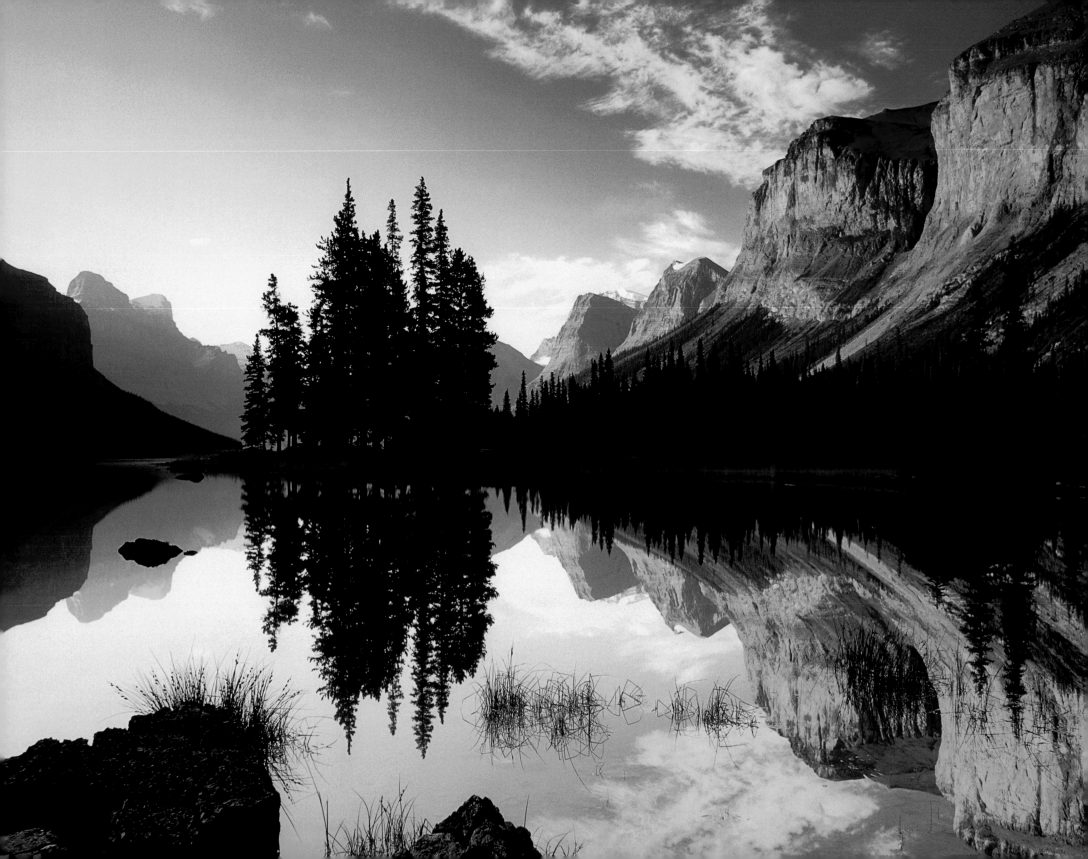

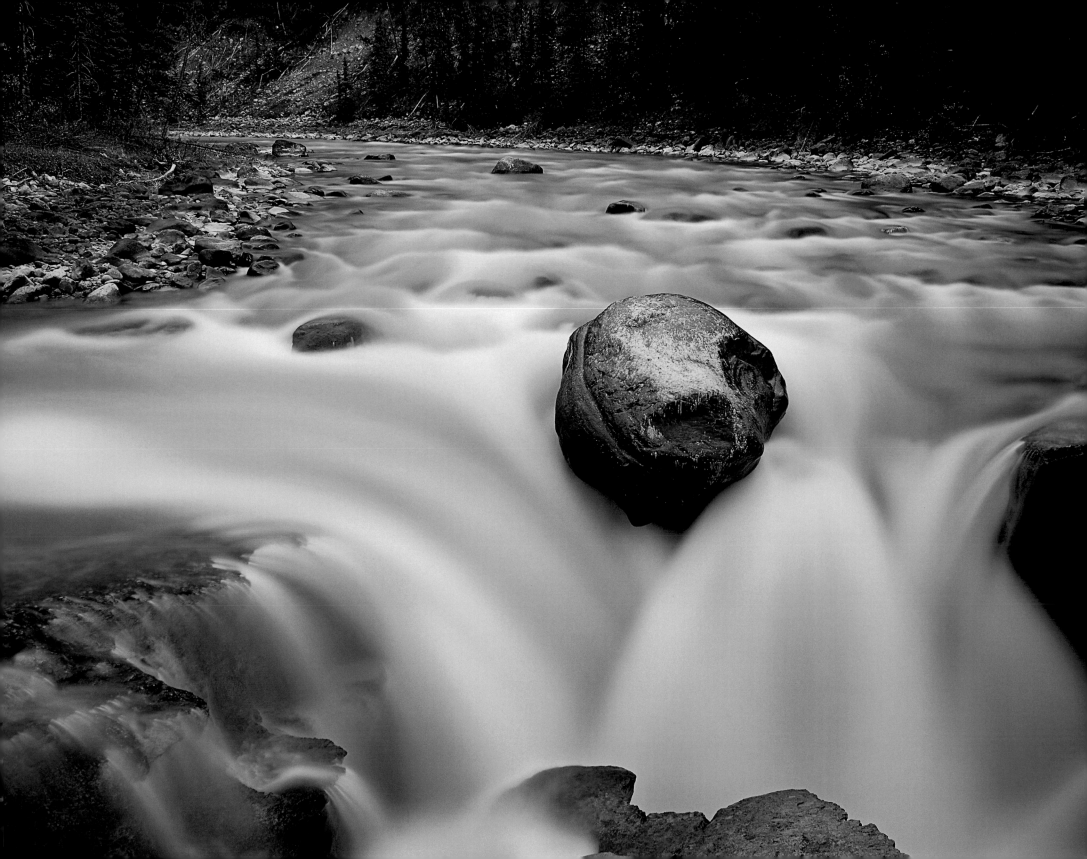

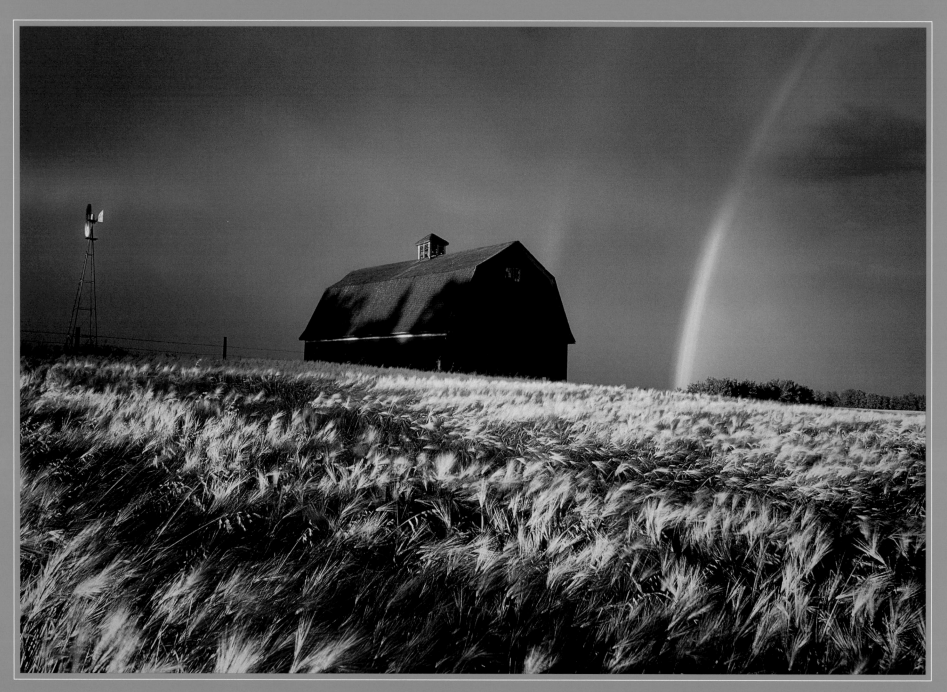

SAME LOCATION, DIFFERENT RAINBOW

Balance

I enjoy summer naps on my living room sofa, especially if accompanied by a late afternoon rain shower. The soothing sound of rain pattering on the shingles combined with a cool breeze wafting through the open curtains sets up a combination of natural sedatives that no true human sloth like myself can resist.

I remember being snapped back to consciousness from one such nap by a loud crack of thunder. My eyes opened to brilliant beams of warm sunlight streaming through the window where earlier there had been only the flat, dark purple of a stormy prairie sky. Instinctively, I jumped up and raced down the hallway to my eastern-facing bedroom windows. Sure enough, the sky in that direction was still dark from the trailing edge of the passing storm. In beautiful contrast to that storm-darkened sky was the arc of a huge double rainbow with colours so intense they could make a bishop kick out a stained glass window in envy.

I quickly grabbed my camera gear, jumped into the vehicle, and raced out of town to a nearby spot I knew would make an excellent foreground for this dramatic display *(other examples of this location are on pages 108 and 110. Unfortunately this windmill has since blown down.)* The rural range road that leads to this location has a posted speed limit of 60 km/h; I have to admit I was pushing 80 km/h as I raced to get in position to photograph the quickly fading show. Unfortunately, by the time I got there the clouds to the west had covered the sun, the light was gone, and so was one of the most dramatic rainbows I had ever seen. The truth is I miss more photographs than I actually get. On the walk back to my vehicle I kicked some old cow patties in frustration. Of course they were now wet from the rain and stuck to my boots.

With that fresh smell of Alberta accompanying me, I moodily drove back down that 60 km/h range road, now only doing about 40 km/h. In the final measure, everything seems to find a balance.

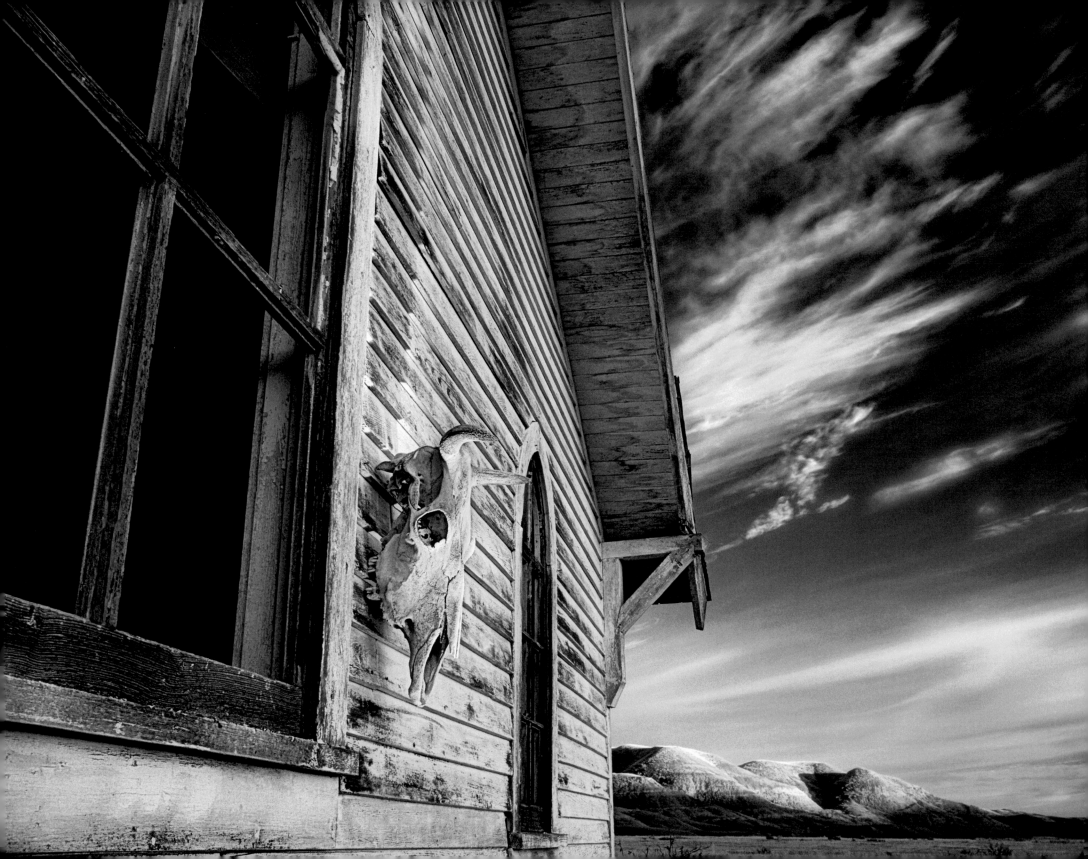

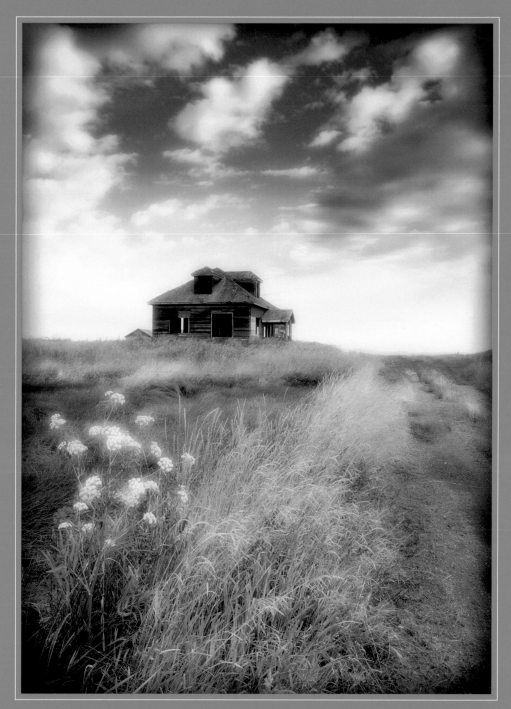

ABANDONED HOMESTEAD,
SOUTHERN ALBERTA

◄ NEAR DOROTHY

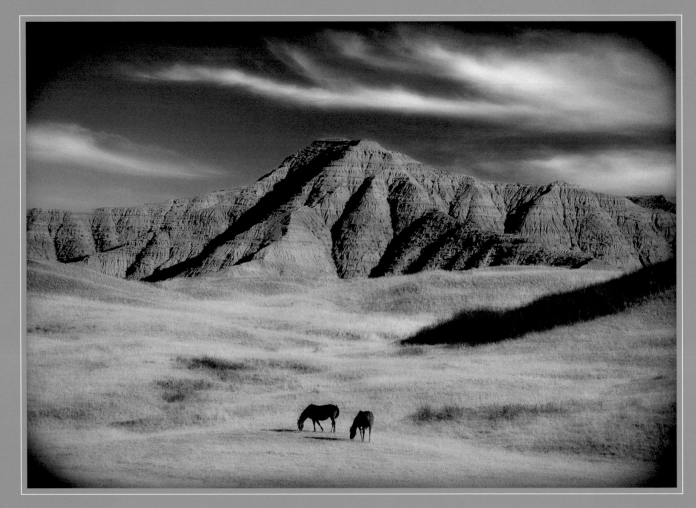

BADLANDS, NEAR FORT MACLEOD

TYRANNOSAURUS REX ON THE PROWL, MILK RIVER, SOUTHERN ALBERTA ➤

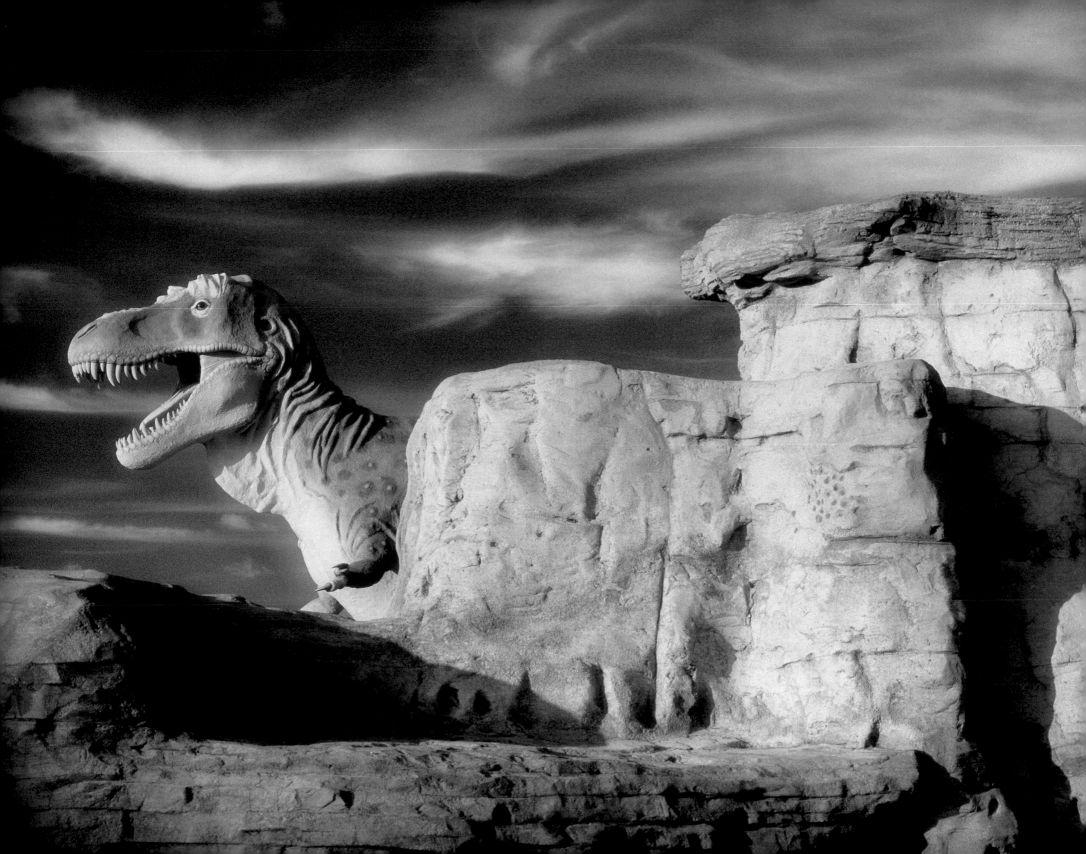

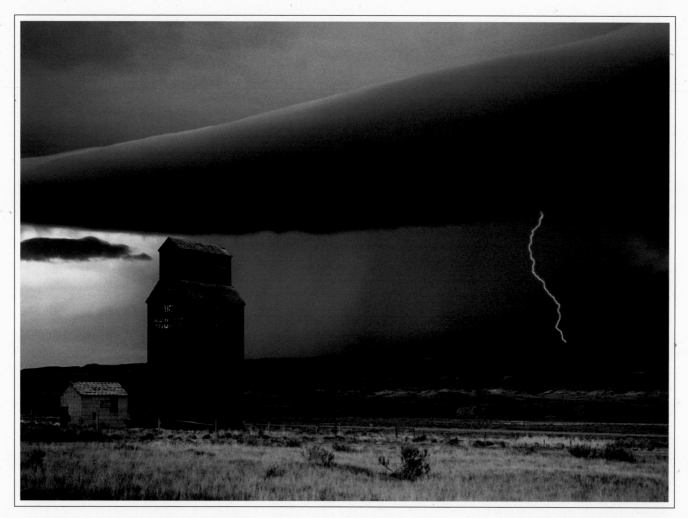

STORM FRONT, DOROTHY

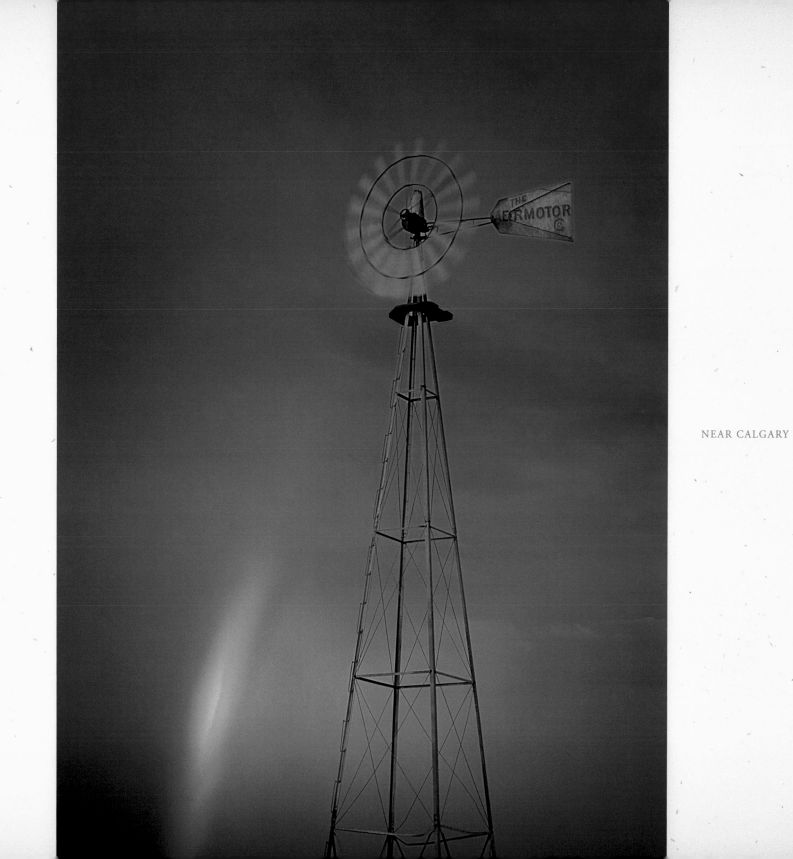

NEAR CALGARY

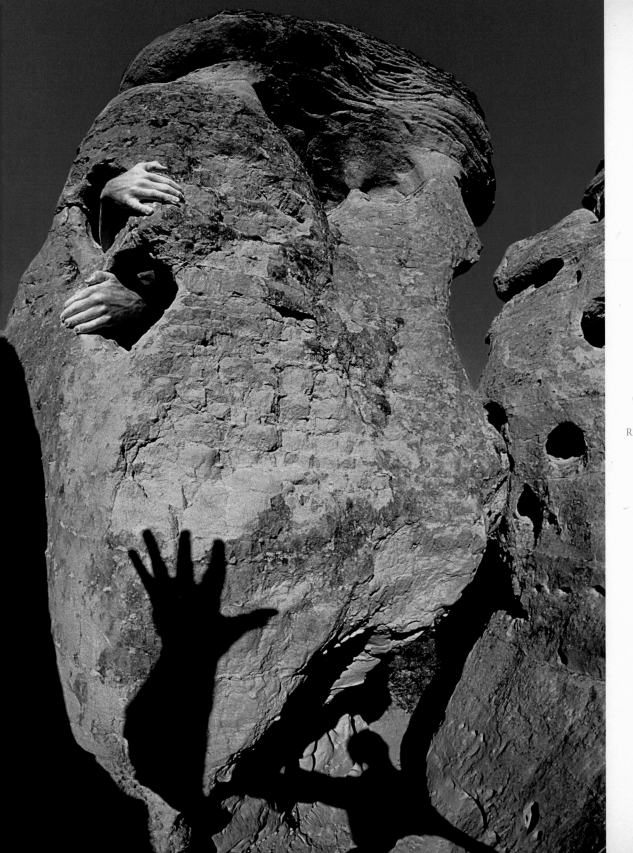

ROCK CLIMBING, WRITING-ON-STONE PROVINCIAL PARK

HANGING OUT, PANTHER FALLS, BANFF NATIONAL PARK ➤

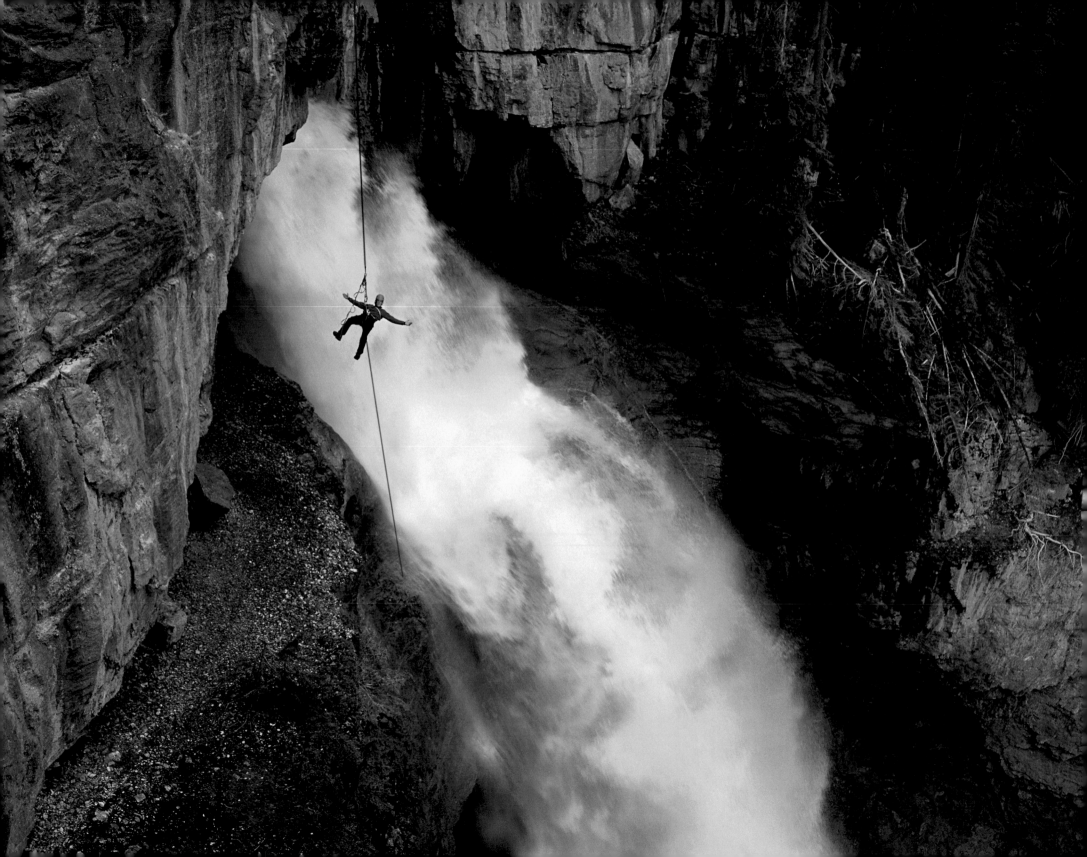

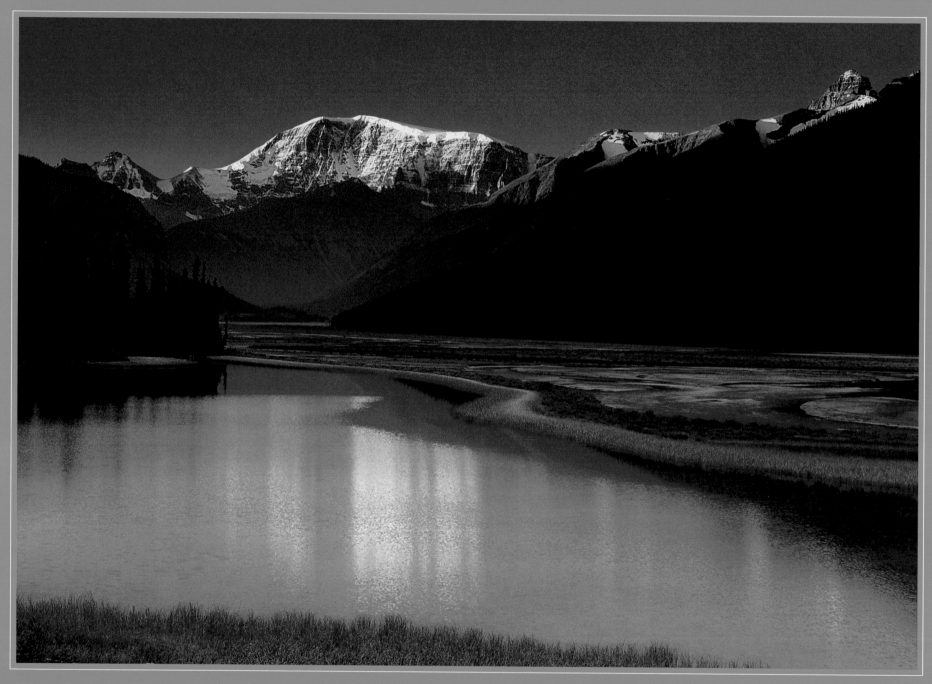

MOUNT KITCHENER FROM RIGHT BESIDE THE HIGHWAY, JASPER NATIONAL PARK

the Cascade Effect

The low, warm light is perfect. You've spotted a gorgeous landscape while driving along the Banff–Jasper Parkway. You pull well over to the side of the road, unpack your camera equipment, and begin to set up your tripod *(the larger the tripod and camera lens, the quicker the Cascade Effect will commence)*. Within a minute of setting up, another couple of vehicles will slow down and then stop, their passengers eagerly scanning the landscape, looking for *"the animal."* This will immediately cause other vehicles to slow down and stop. Soon a tour bus will pass, slow down, and stop. The Cascade Effect is now officially underway, and before long—only a couple of minutes in peak tourist season—you and your tripod will be in the midst of a huge traffic bottleneck!

There is only one remedy I'm aware of to prevent the Cascade Effect from ever getting started. Before you go out to photograph in the national parks, make a large sign for your vehicle's rear window that reads, *"There Is No Animal! I Am A Landscape Photographer—It's Okay To Feed Me!"*

Alberta

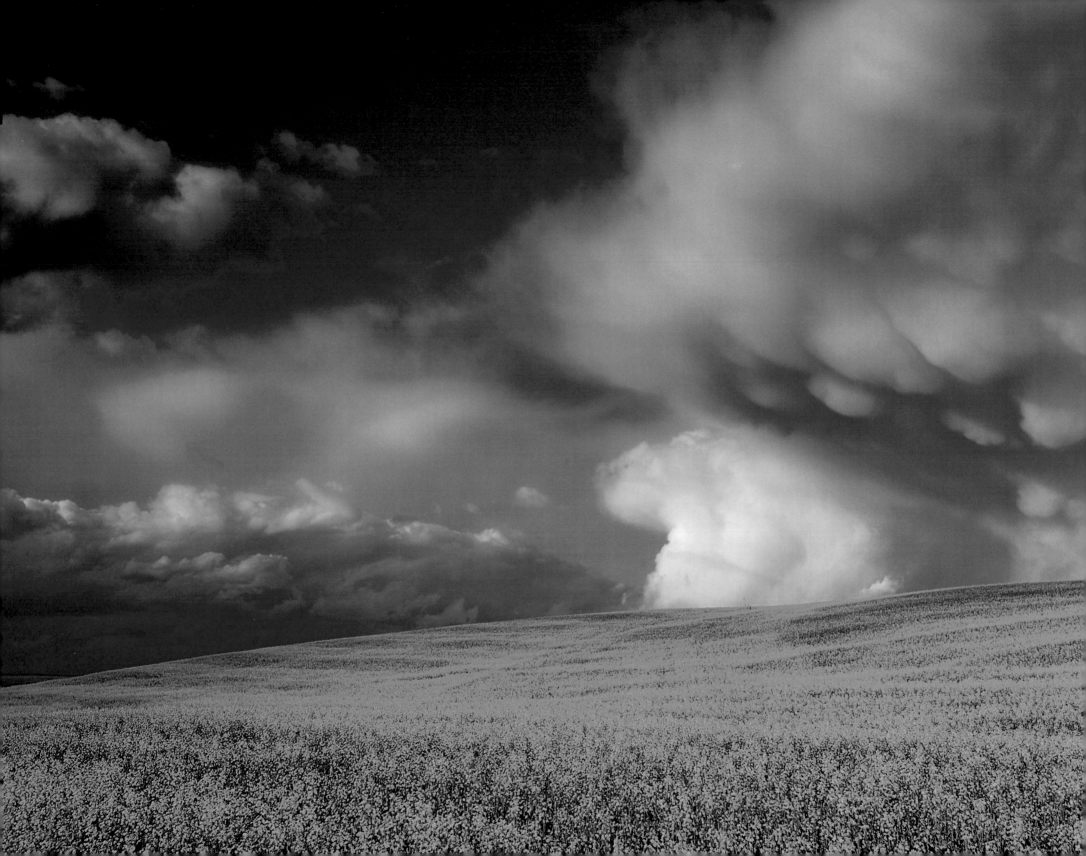

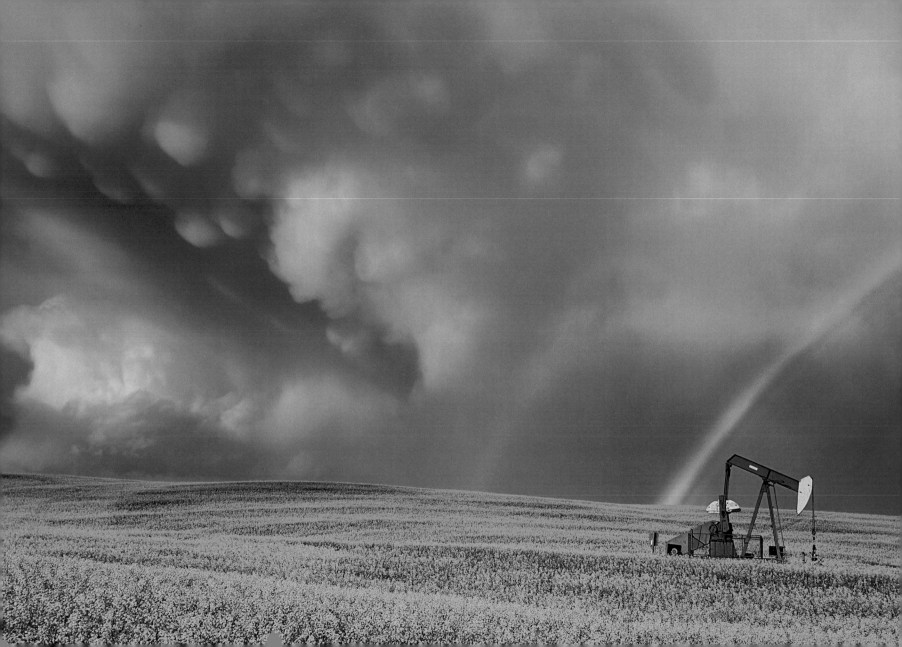

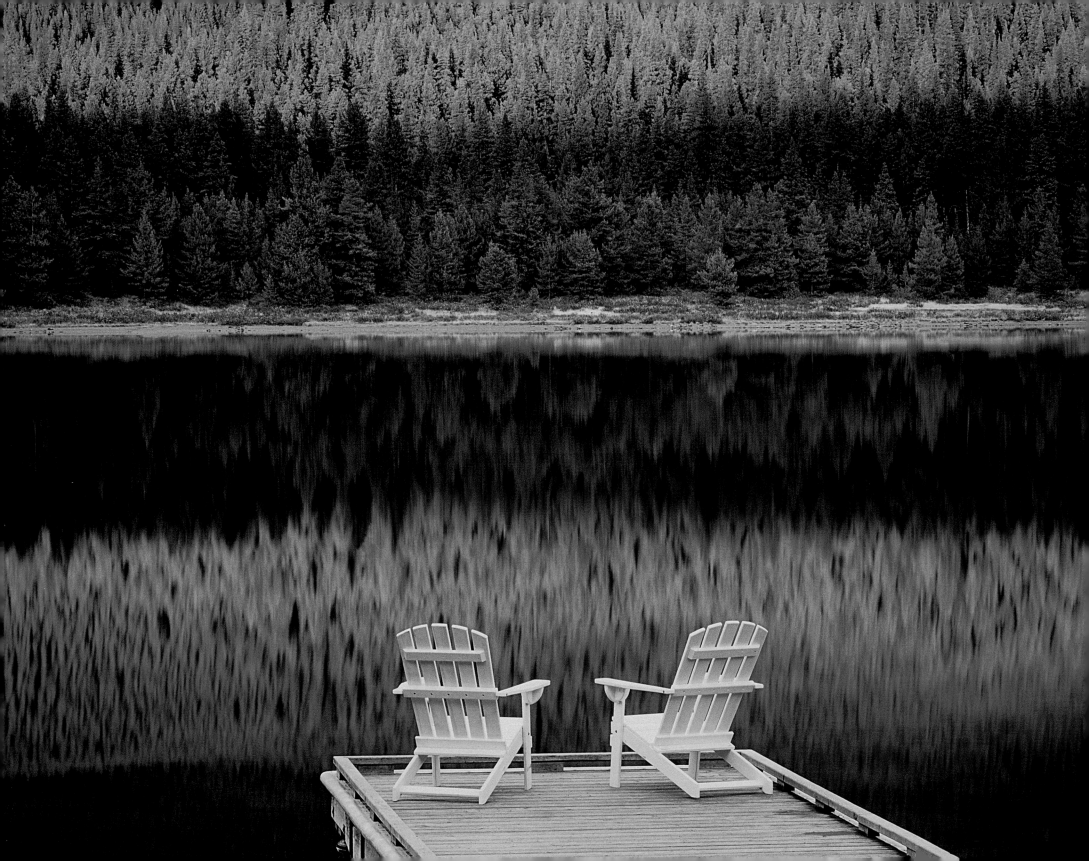

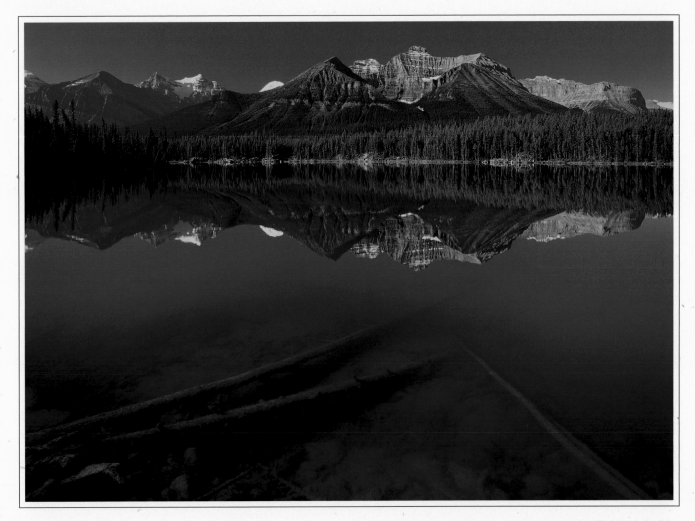

BOW RANGE, HERBERT LAKE, BANFF NATIONAL PARK

◄ MALIGNE LAKE, JASPER NATIONAL PARK

Alberta

Friendly Folk

One of the notable things about driving the rural, gravel, back roads of Alberta is how friendly the locals are. Everyone will give you the famous one-finger farmer's wave as they drive by in their pickups (no, not *that* finger). To perfect the farmer's wave, place your hands on the steering wheel at eleven and one o'clock. Now, as an oncoming vehicle approaches, wait until you can almost make out the logo on the driver's ball cap, then partially extend your left index finger while simultaneously nodding your head an almost imperceptible two centimetres. Congratulations, you've just mastered the farmer's wave, a second language of genuine value in most any rural Alberta community.

Alberta

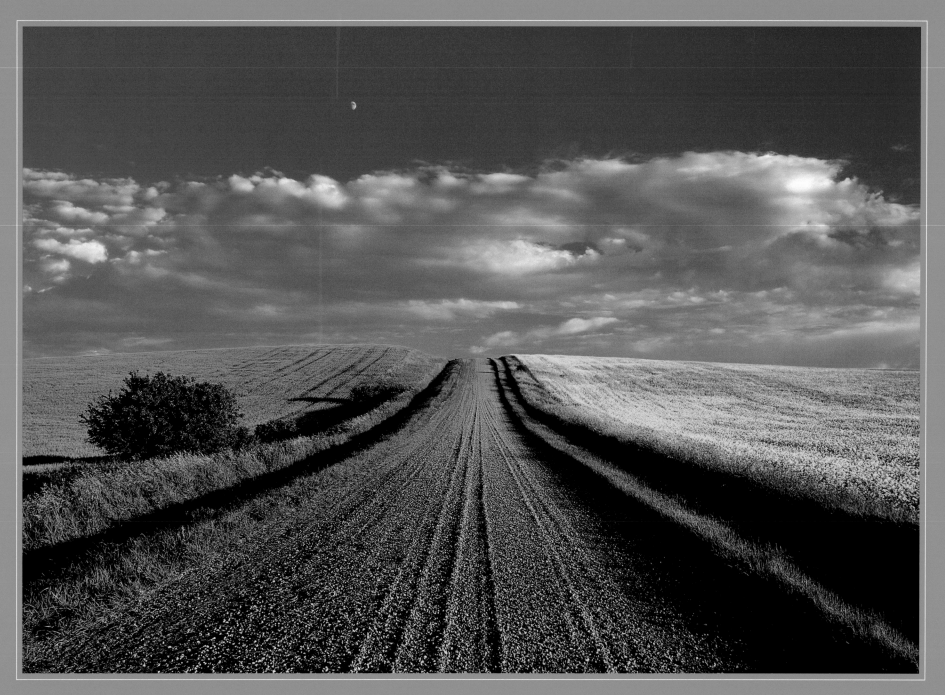

LATE AFTERNOON, NEAR ELK POINT

Autumn

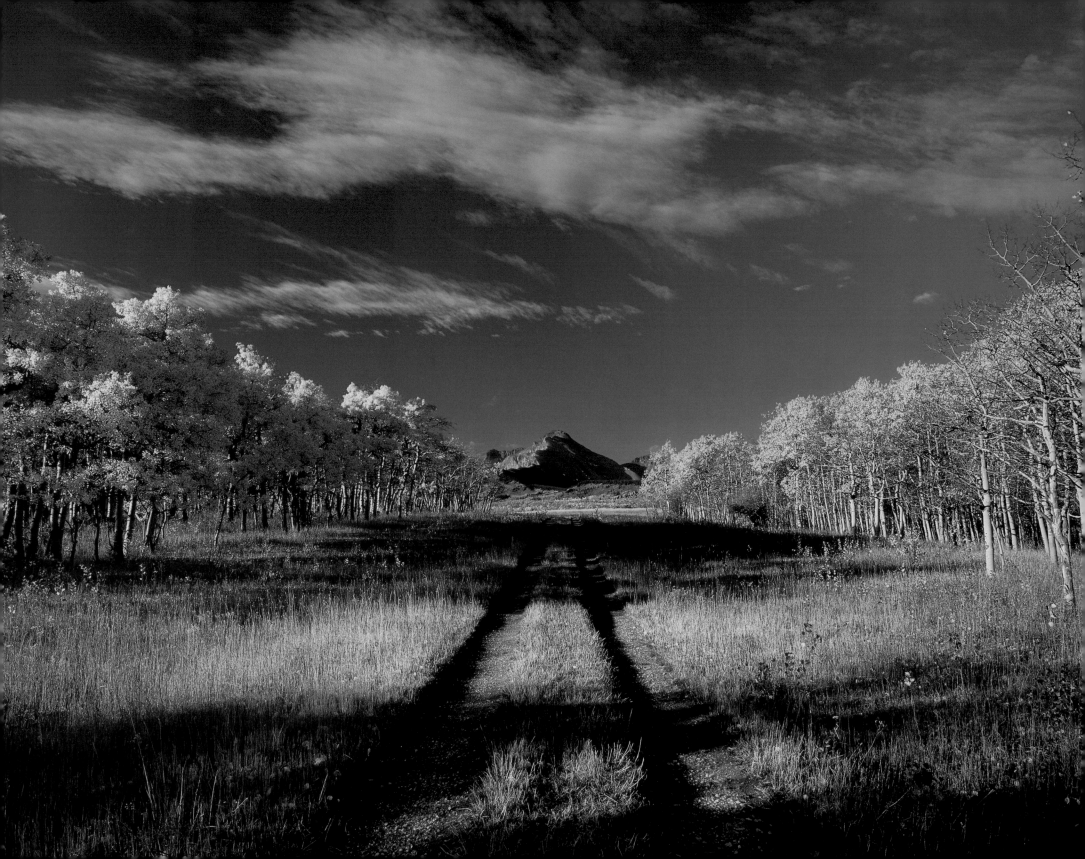

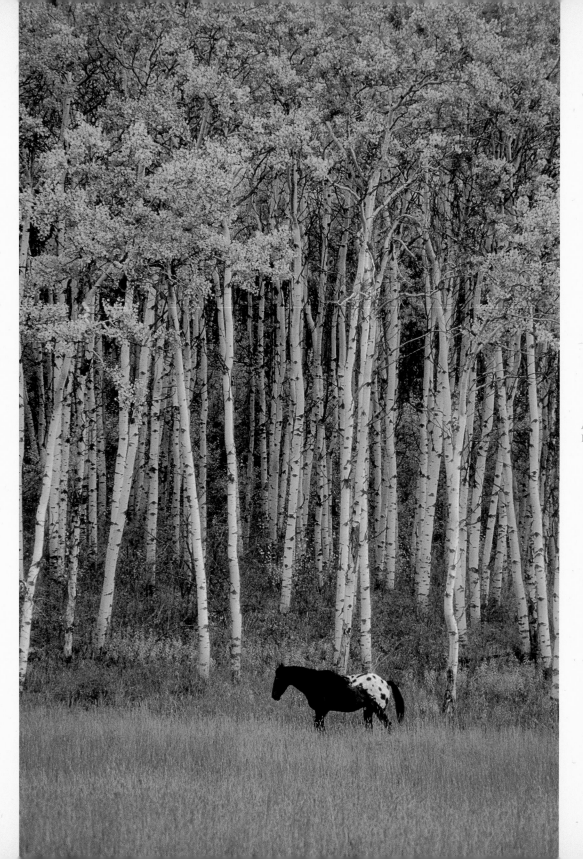

APPALOOSA AND ASPEN,
NEAR TURNER VALLEY

◄ NEAR WATERTON LAKES
NATIONAL PARK

Bad Bologna

"Honey!" I holler from the kitchen. *"How old is this bologna in the fridge?"* Her response rises from the basement, *"It should be fine. I only bought it a week ago."* Hmmmm, I think to myself, it smells a little funny, but I don't like wasting food, and besides, I'm always bragging about my cast-iron gut. I pull off a couple of thick slices and make myself a huge Dagwood-style sandwich. About an hour later, I begin to realize that I suffer from a gross overconfidence in my cast-iron gut, and I'm reminded of my inability to spot the varying shades of green that bad bologna turns. This slight red-green visual colour deficiency is not an unusual problem (about 10% of the male population has this minor genetic malady). Perhaps to compensate for this slightly desaturated vision, I usually prefer strong graphic colours in my images. I've often been accused of exaggerating or overemphasizing certain hues. All I can honestly say is—they look fine to me!

Alberta

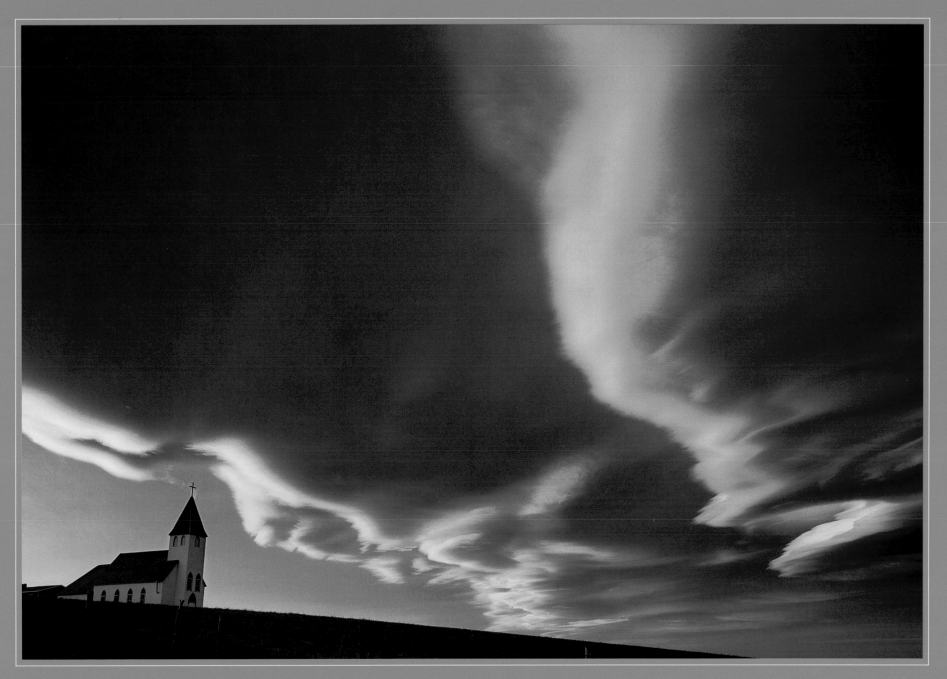

LENTICULAR CLOUDS, SUNSET, NEAR TWIN BUTTE

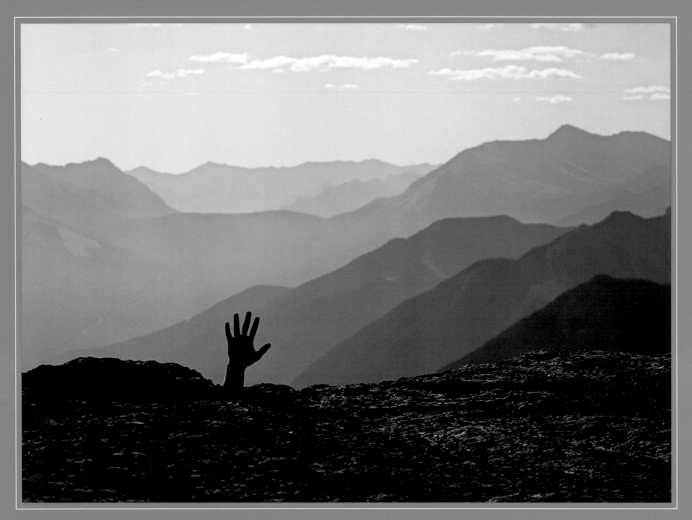

SOUTH END OF MOUNT RUNDLE, NEAR CANMORE

MOUNT CHEPHREN, BANFF NATIONAL PARK ➤

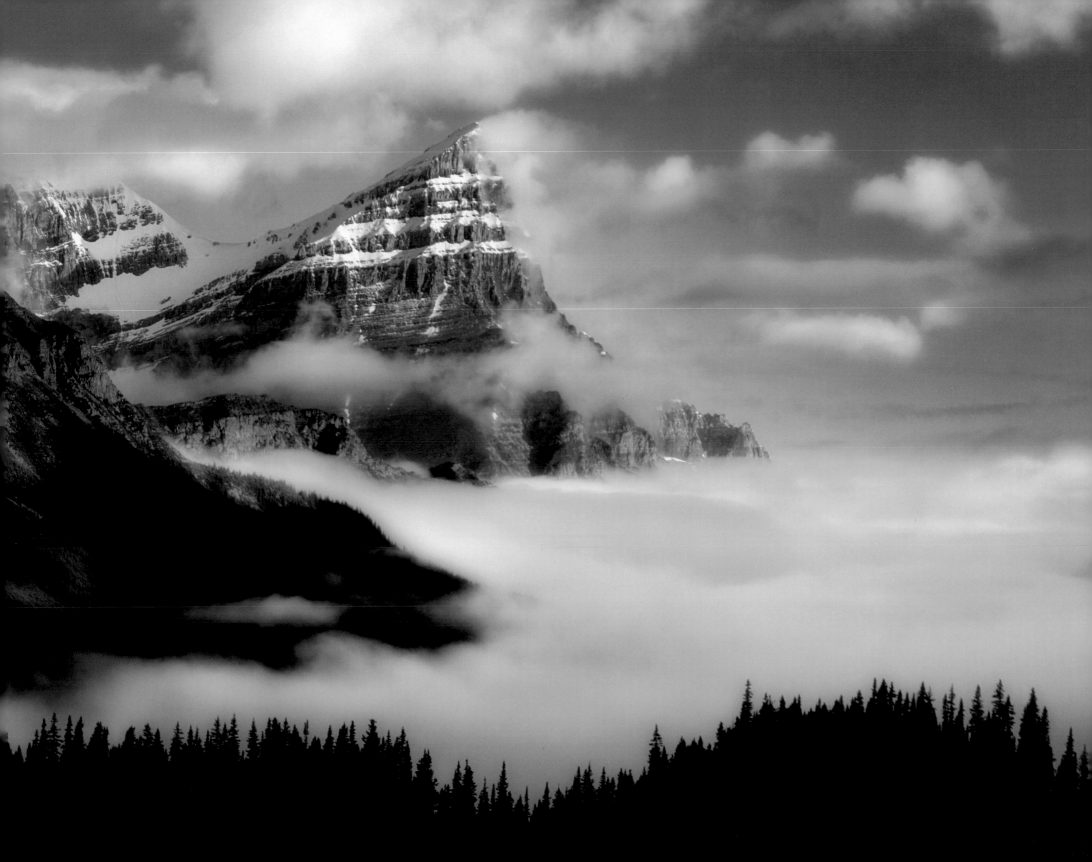

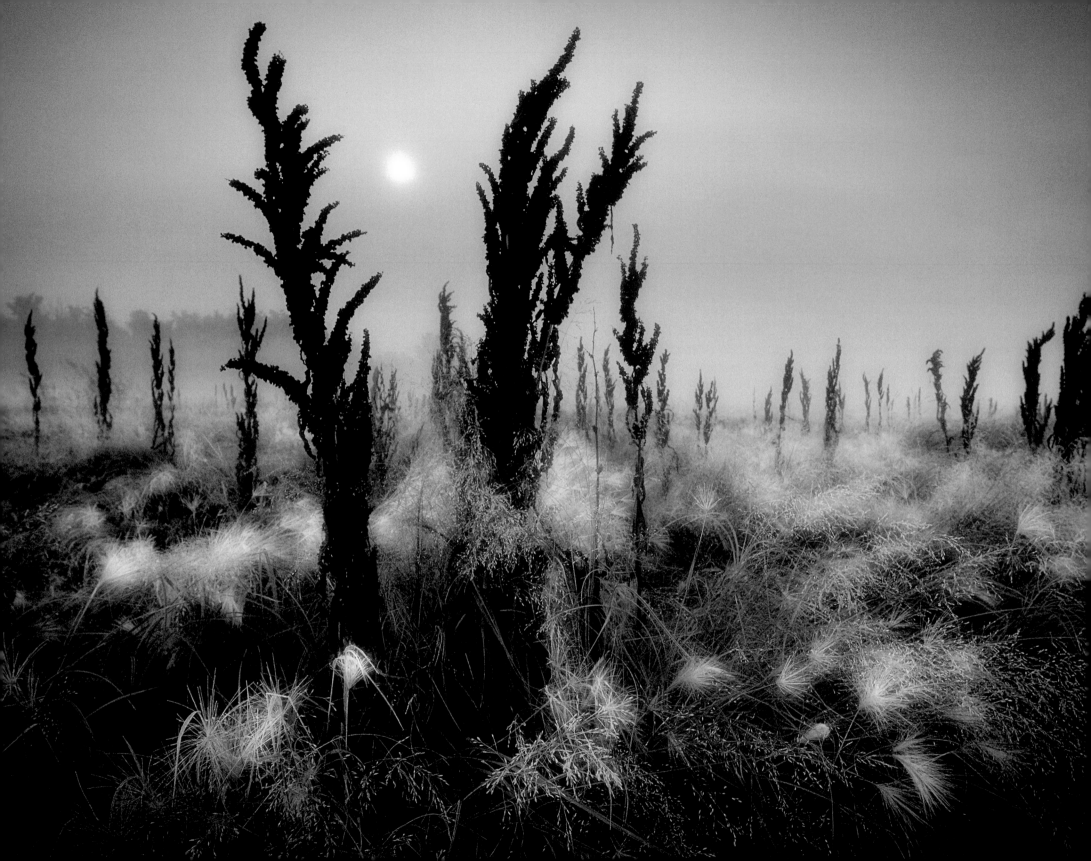

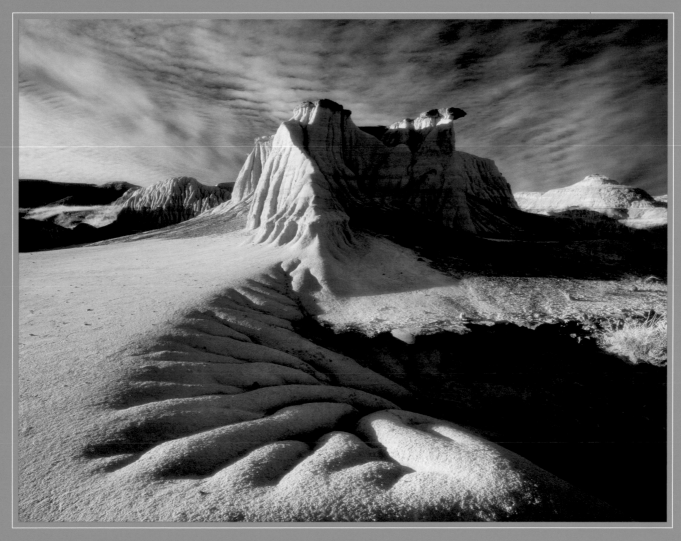

BADLANDS, DINOSAUR PROVINCIAL PARK

◄ WESTERN DOCK, SETTING MOON AT DAWN, NEAR SHERWOOD PARK

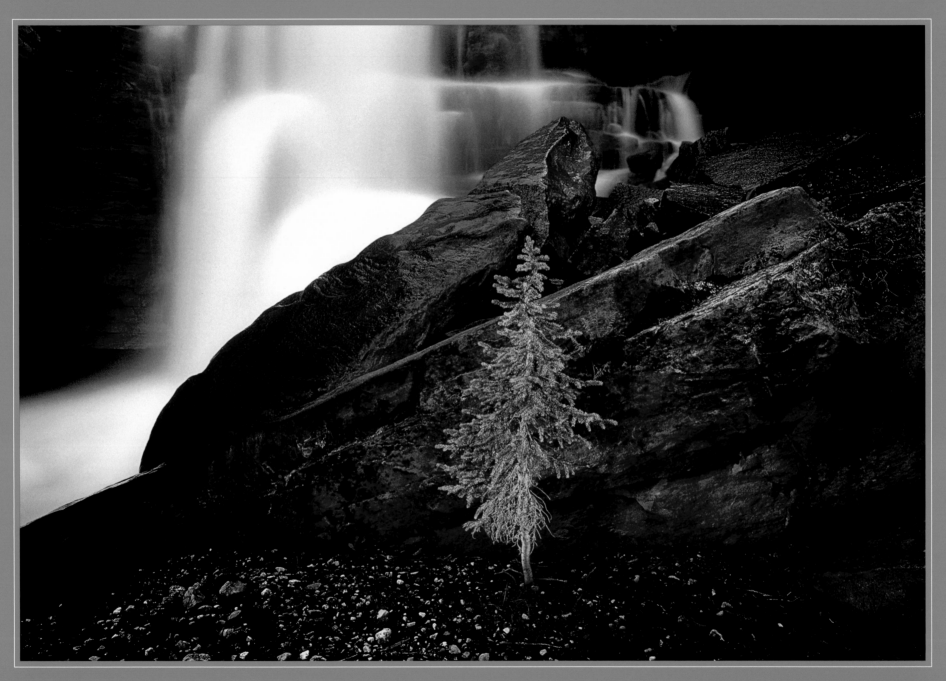

SHADOW CREEK FALLS, BANFF NATIONAL PARK

the Silence was Deafening

We had spent most of the day hiking and photographing around Shadow Lake Lodge in Banff National Park. It was a perfectly calm, quiet night as we bunked down. The air was so still that the silence seemed almost deafening. An hour after lights out I was still wide awake. In the stillness of that night and on the very edge of audibility, I swear I could hear tiny whispering voices floating in from outside the cabin. After a moment or two of straining to make sense of these phantom noises, I whispered to a friend in the next bunk, not even sure if he was still awake. *"Ron,"* I asked, *"do you hear voices?"* His response was brief and immediate. *"Always!"* was all he said.

Alberta

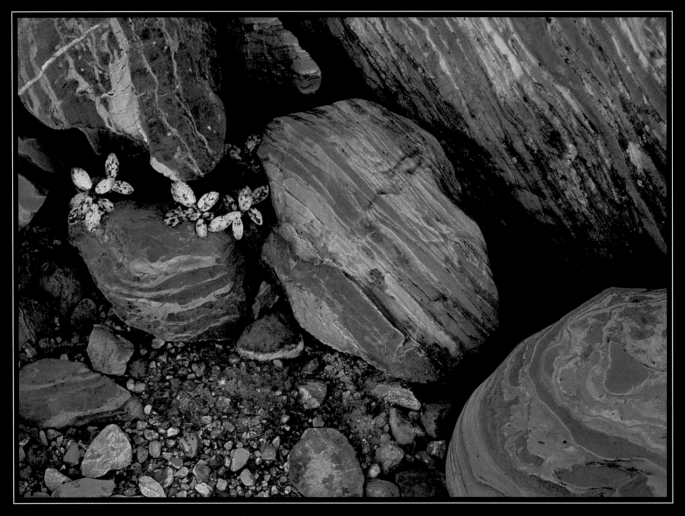

ATHABASCA GLACIER MORAINE, JASPER NATIONAL PARK

WILCOX PASS, JASPER NATIONAL PARK ➤

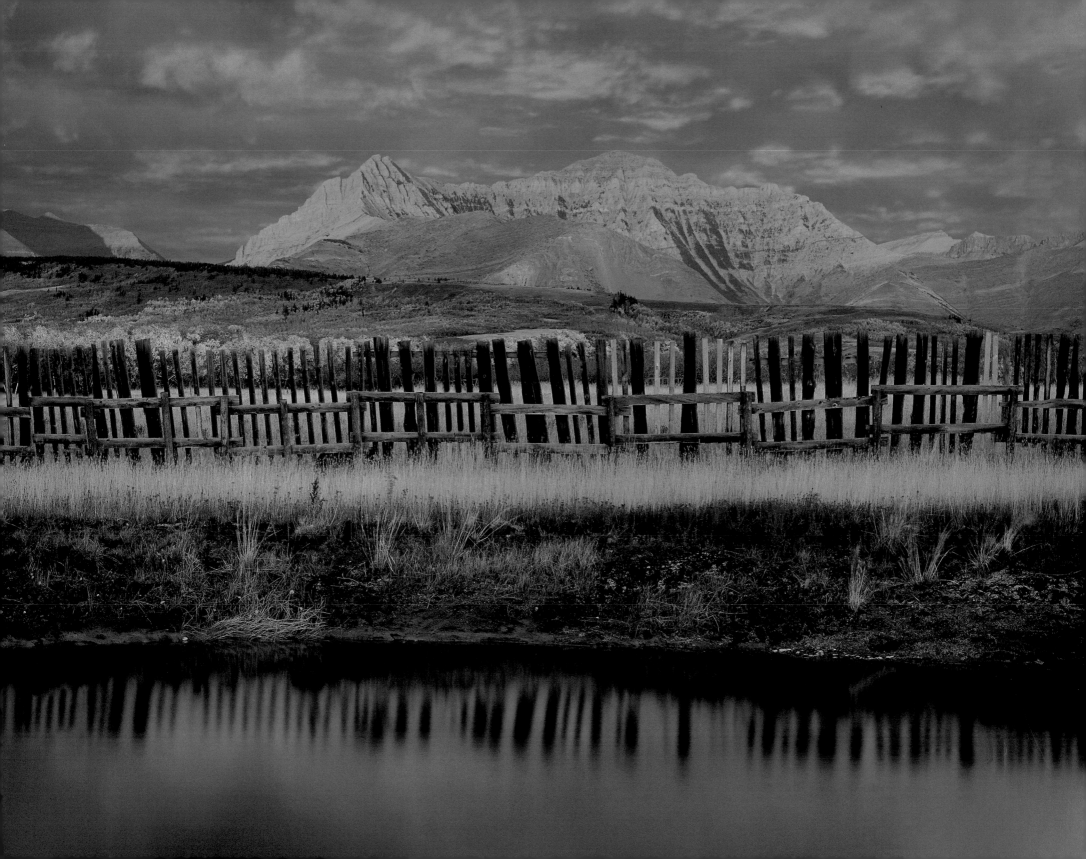

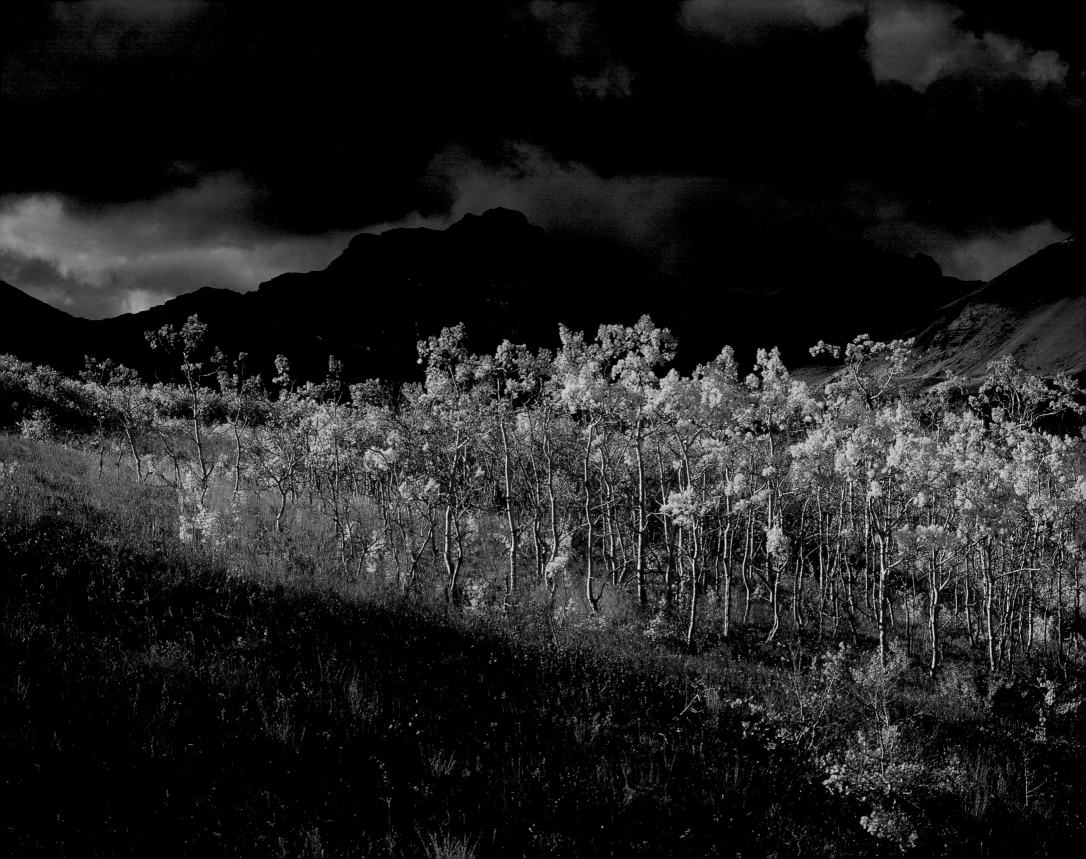

AUTUMN, NEAR WATERTON LAKES NATIONAL PARK

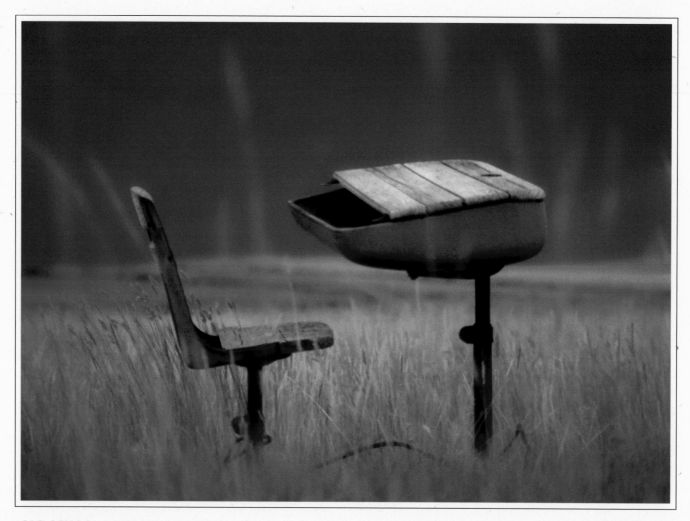

OLD SCHOOL DESK, NEAR CLARESHOLM

Alberta

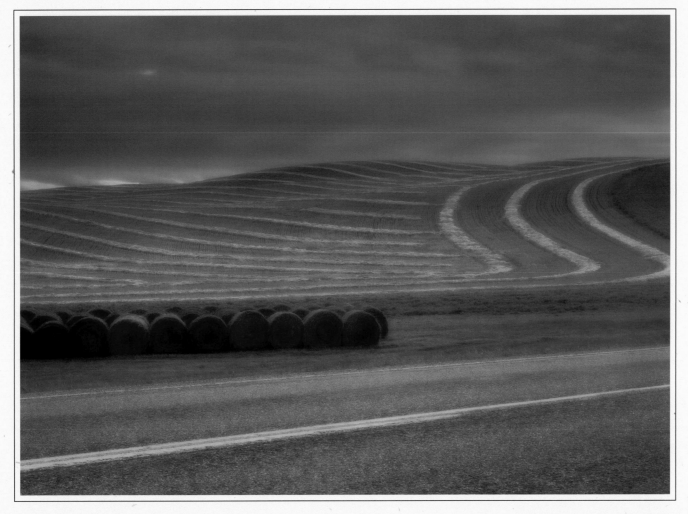

HWY. 41, NEAR CONSORT

Alberta

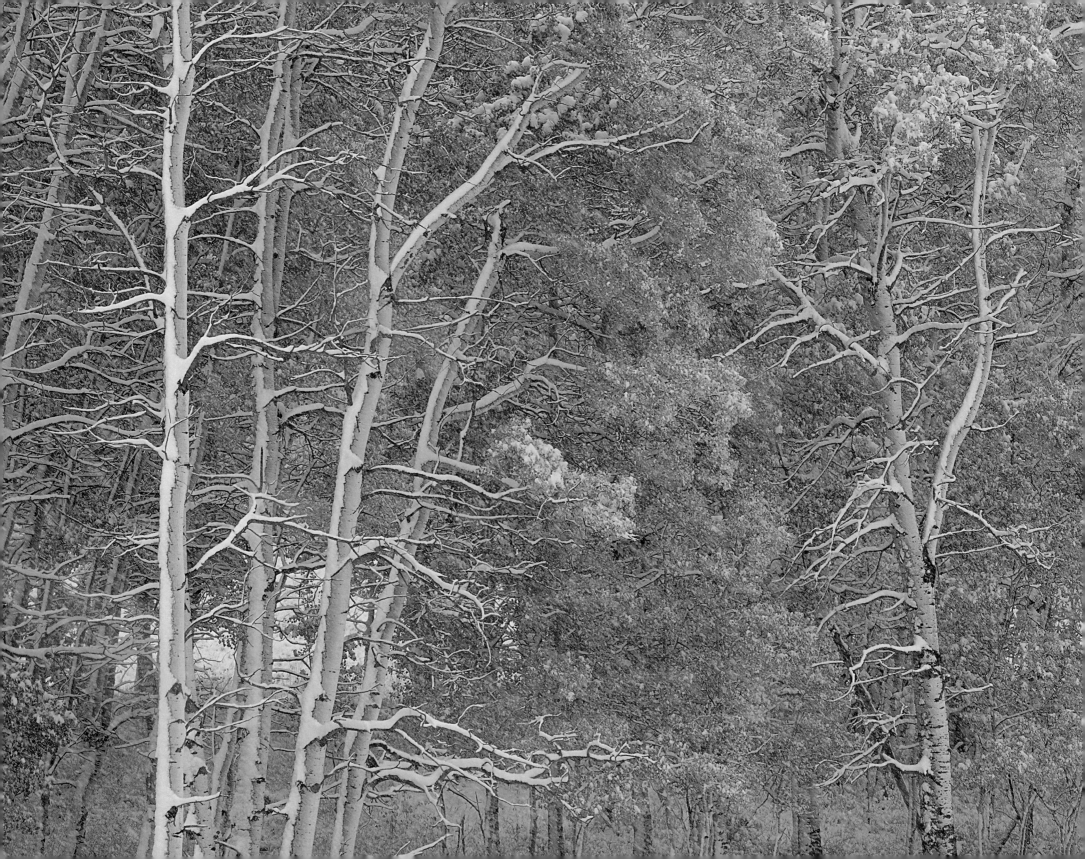

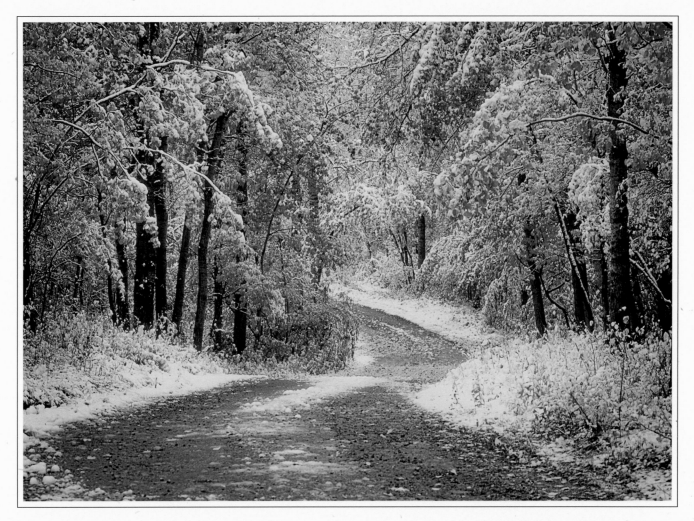

RURAL BACK ROAD, NEAR BEAUMONT

◄ EARLY SNOWFALL, KANANASKIS COUNTRY

Alberta

Recognize the Beauty

I arrived early at the Moraine Lake parking lot on a calm, overcast September morning. A light sugar-dusting of snow covered the entire mountain landscape. I was eager to get up the trail to Larch Valley. I had never been there before but had seen many wonderful images of the area with the larch trees in full autumn display. Larches are the only conifers that turn colour in autumn—a beautiful yellow-gold—and then lose their needles over the winter.

Some of the views right by the lake and trailhead were nice, so I stopped just long enough to set up the tripod and snap off a couple of quick shots. But I knew better images awaited me, so I quickly and anxiously lusted up the trail toward Larch Valley.

When I finally reached the upper valley, I was disappointed to see that the larch had not yet turned colour. In fact, the change had barely begun. Most of the needles were a pale lime-green and in the dull light of the low, overcast sky the entire landscape seemed bland and unappealing. I poked around for a couple of hours, trying to find something to photograph until it finally dawned on me that, in my haste to get up there, I had left a beautiful shooting situation back down the trail at the lake.

It was past noon by the time I made it back to where I had started the day. The slight dusting of snow, which earlier had added visual contrast and drama to the landscape, had now blown away, as had the lake's calm reflections.

The strange thing is, I can write this, but I still make the same error of judgment in not recognizing the beauty that is so often right in front of me.

Alberta

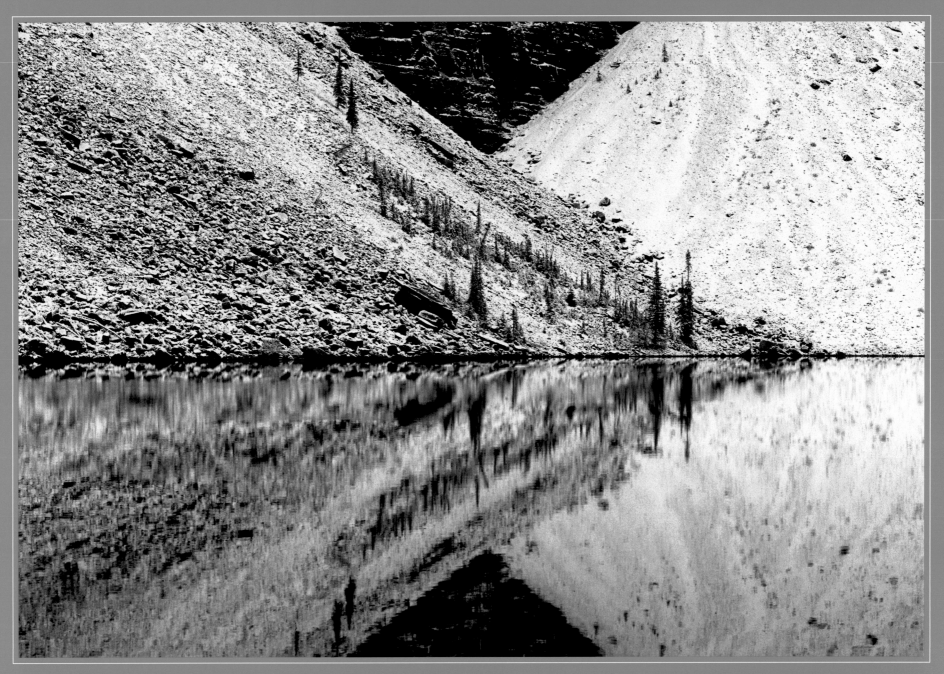

WHERE THE SCREE HITS THE FAN, MORAINE LAKE, BANFF NATIONAL PARK

Winter

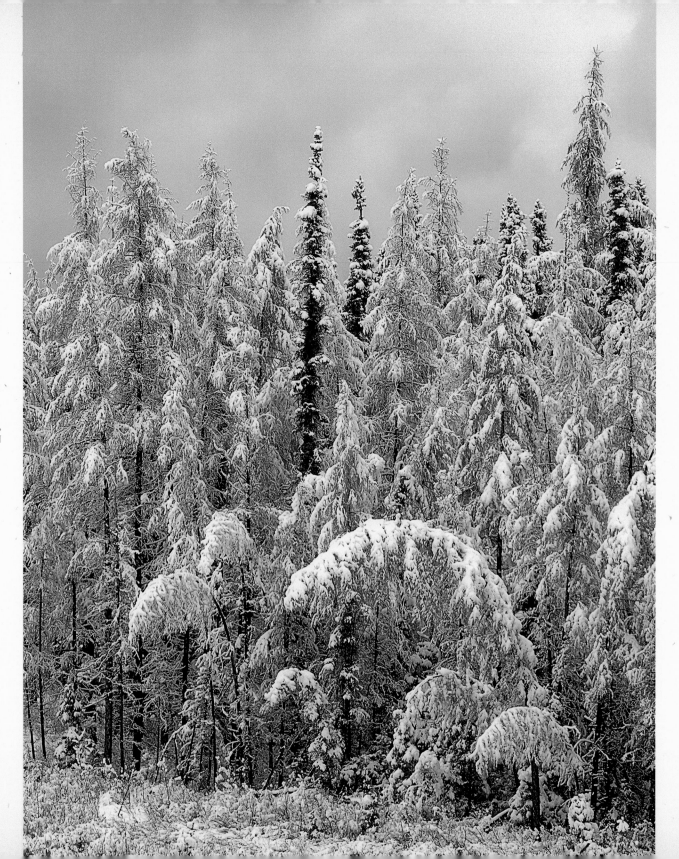

FRESH SNOWFALL ON LARCH,
NEAR EDSON

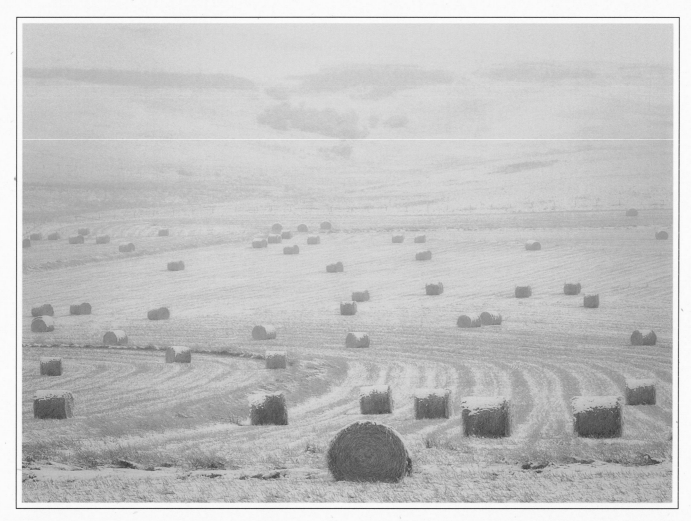

HAY BALES, NEAR LONGVIEW

Alberta

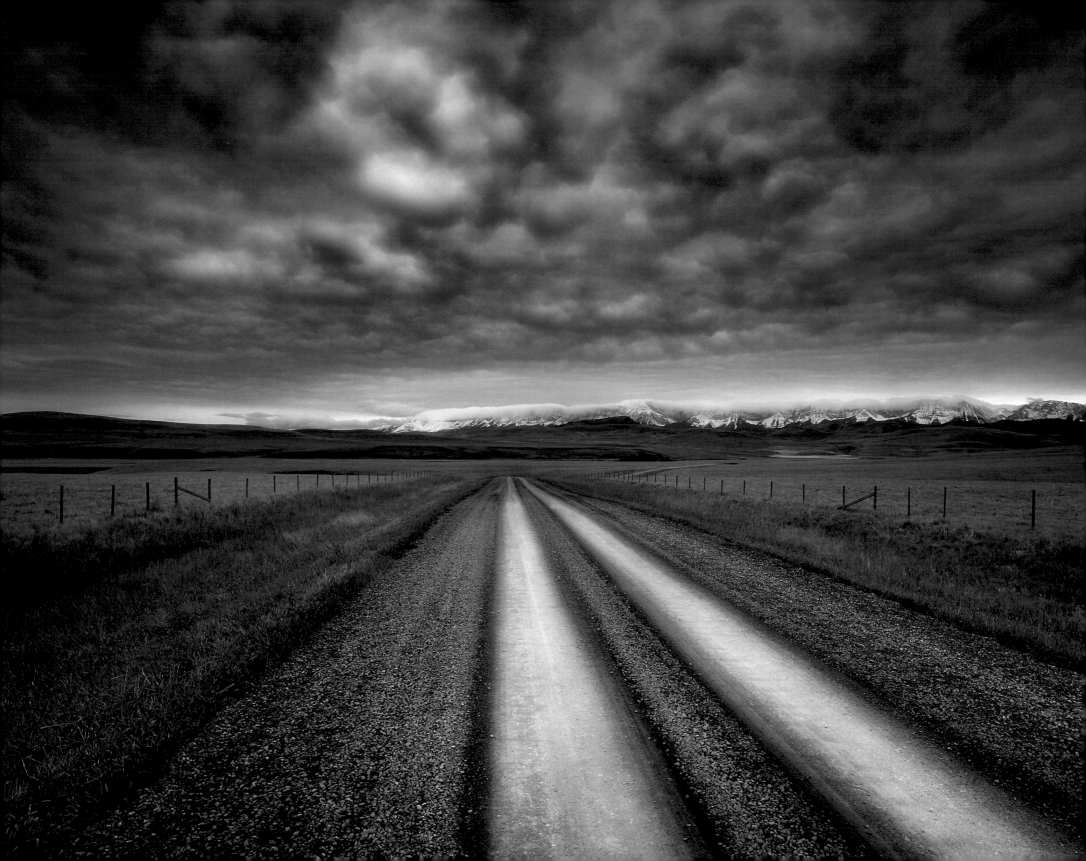

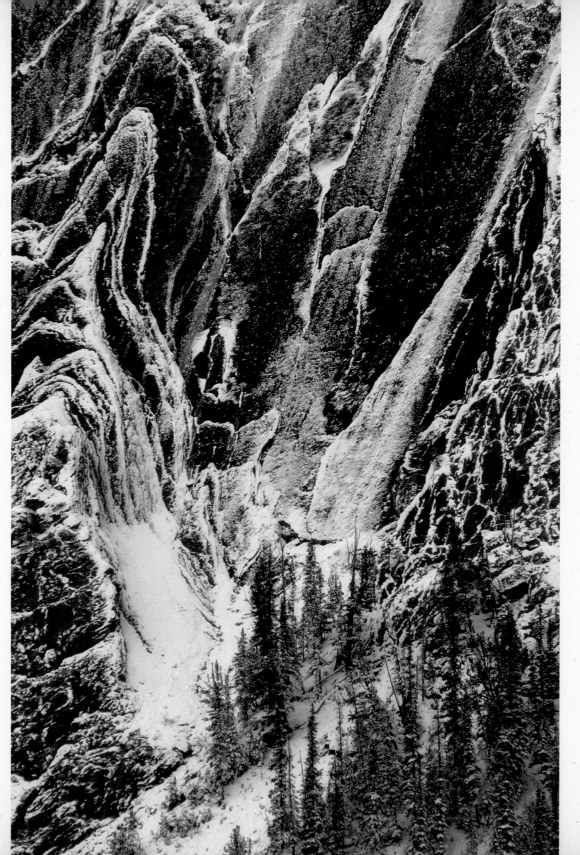

NEAR THE BIG BEND, HWY. 93,
BANFF NATIONAL PARK

◄ APPROACHING WINTER
STORM, NEAR BEAUVAIS
LAKE PROVINCIAL PARK

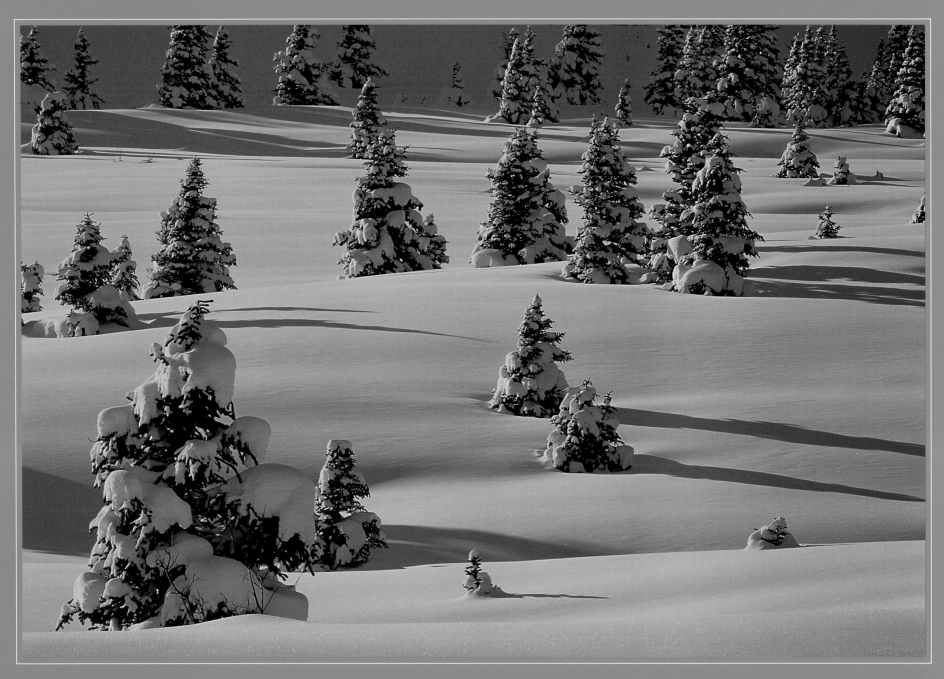

NEAR BOW SUMMIT, BANFF NATIONAL PARK

This Food Sucks!

After a cold winter morning photographing near Bow Summit in Banff National Park, I met a good friend for breakfast at the beautiful Num-Ti-Jah Lodge. The meal started with poached eggs smothered in a velvety hollandaise sauce and large slices of potato fried in butter and sprinkled with salt, fresh cracked pepper, and rosemary. The bread was made fresh that morning, its warm smell still drifting through the lodge. I lingered over several cups of freshly brewed coffee while licking the remaining juicy bits of bacon off my fingertips. I have always claimed that eating a meal with only knife and fork was akin to making love through an interpreter—sometimes you've just got to get your hands in there and enjoy the experience with all your senses! This was a meal not to be forgotten. What turned it into a memory I'll carry forever is the exchange that happened next. My friend knew the chef well and on our way out he jokingly yelled back toward the kitchen, *"Hey buddy, this food sucks!"* The chef's response came back without hesitation: *"Next time you stop by I'll put the food in the blender for ya—that way it'll suck easier!"*

Alberta

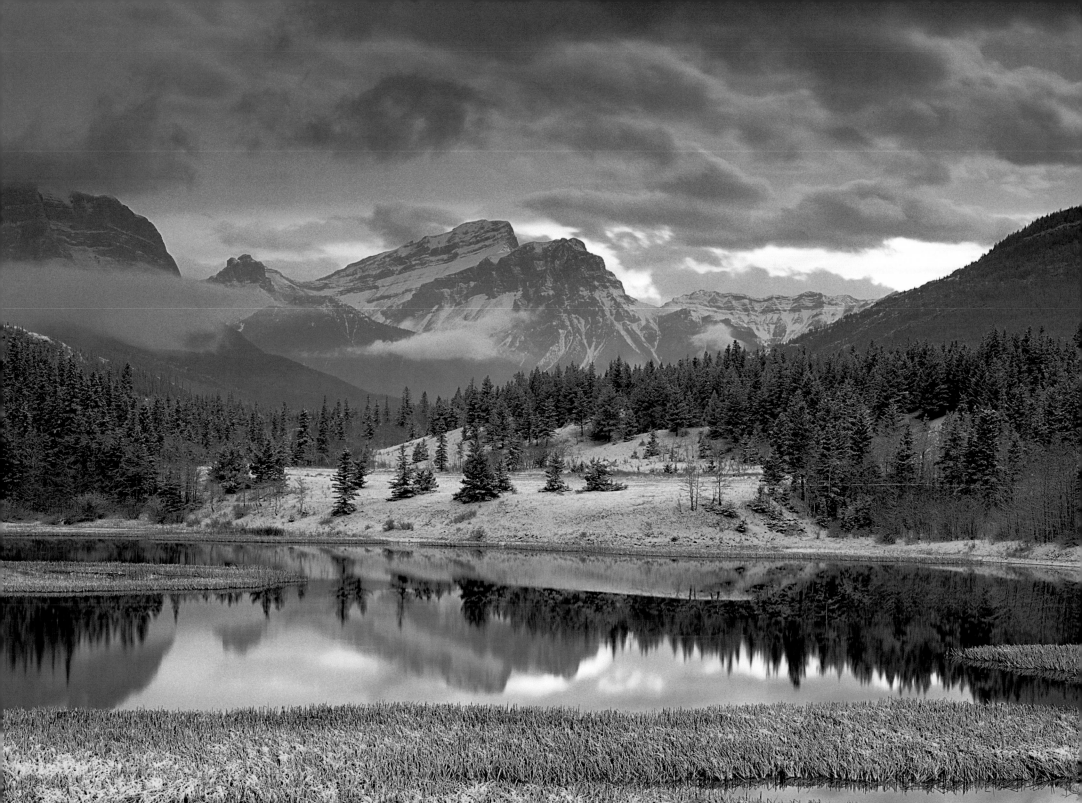

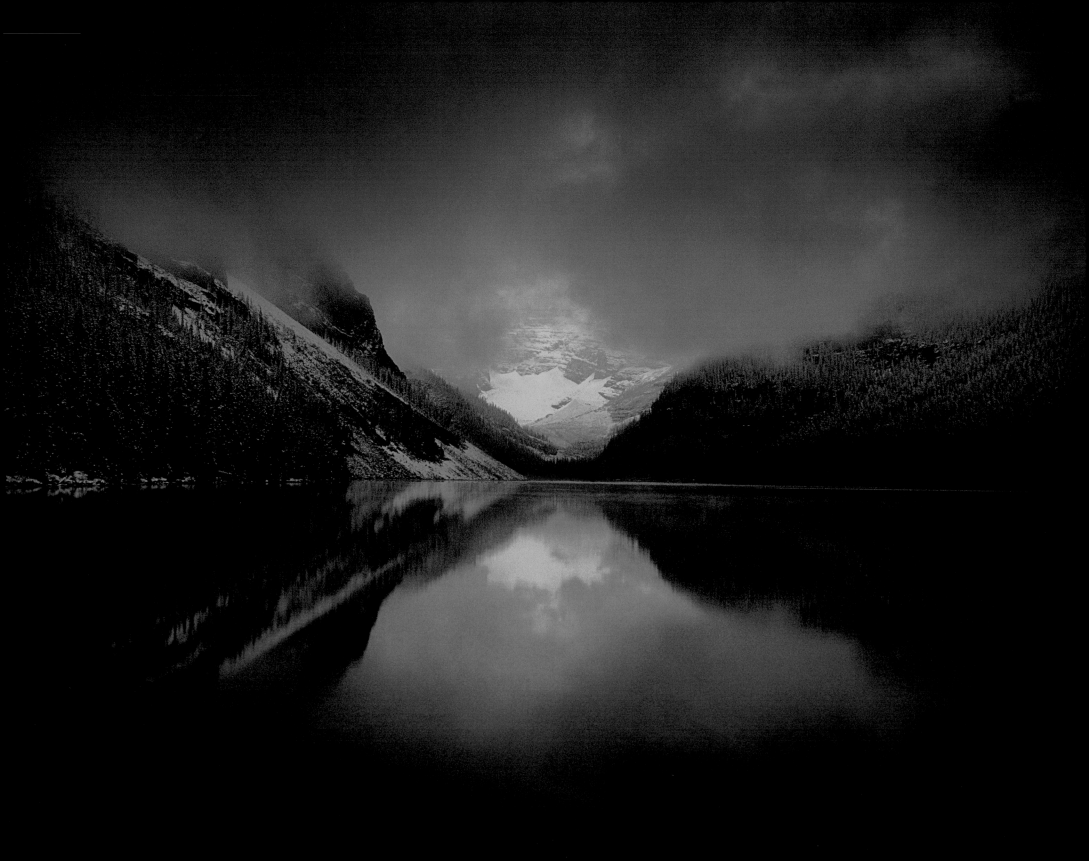

BRIEF MORNING LIGHT ON VICTORIA GLACIER, LAKE LOUISE, BANFF NATIONAL PARK

ATHABASCA FALLS, JASPER NATIONAL PARK

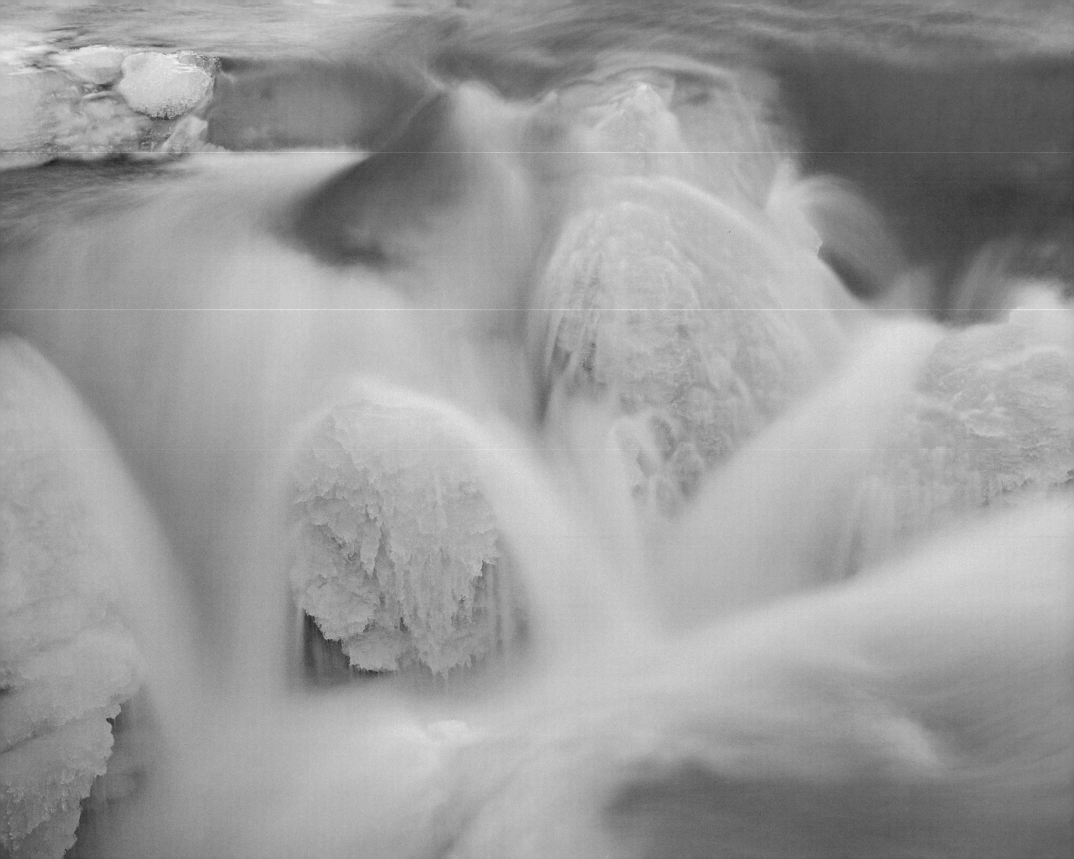

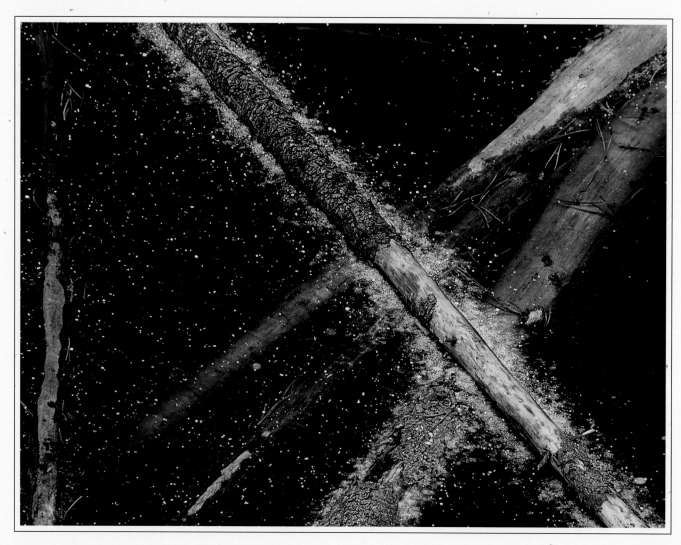

LOG JAM FROZEN IN POOL, SUNWAPTA RIVER, JASPER NATIONAL PARK

Alberta

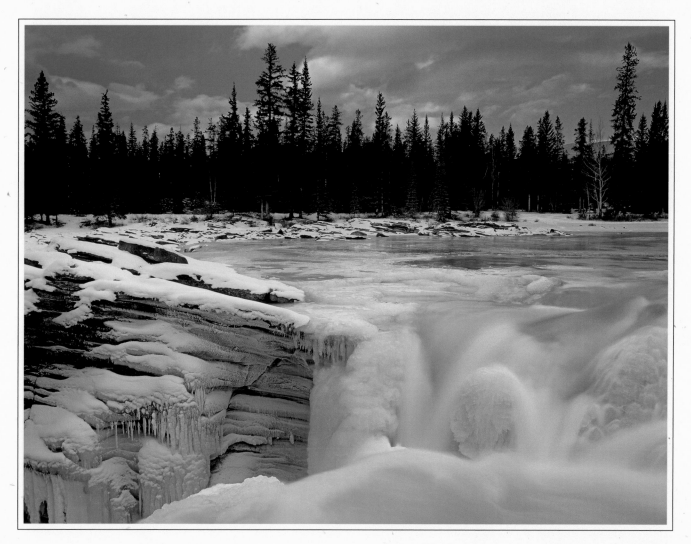

ATHABASCA FALLS, JASPER NATIONAL PARK

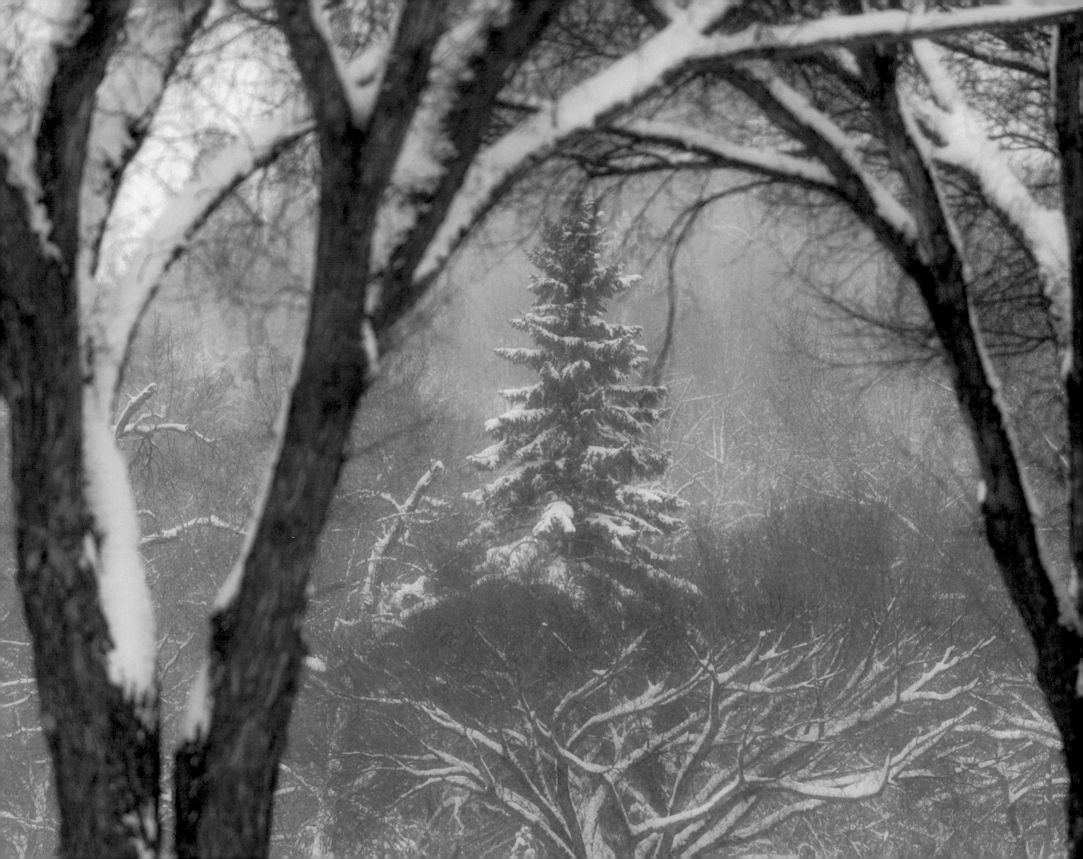

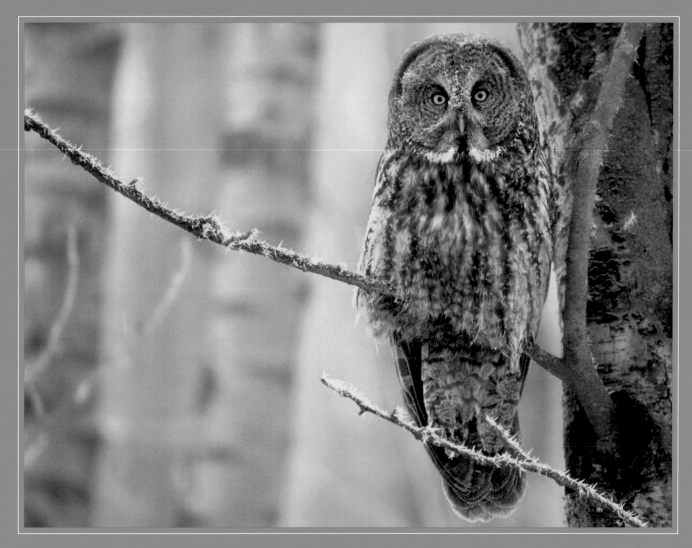

GREAT GREY OWL, ELK ISLAND NATIONAL PARK

◄ EDMONTON RIVER VALLEY

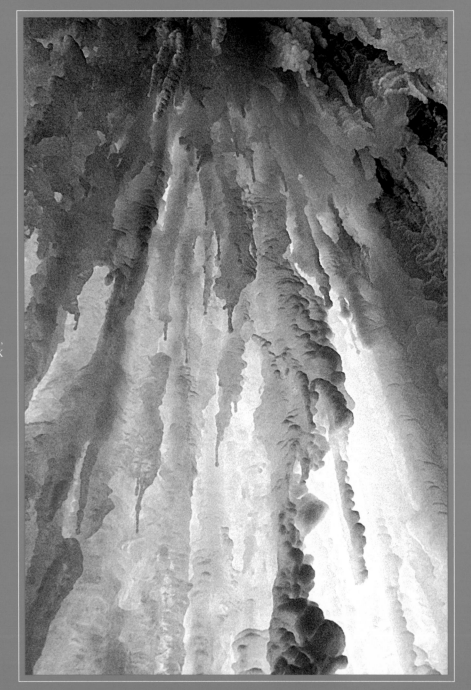

ICE CHANDELIER, MALIGNE CANYON,
JASPER NATIONAL PARK

NEAR SASKATCHEWAN ►
RIVER CROSSING,
BANFF NATIONAL PARK

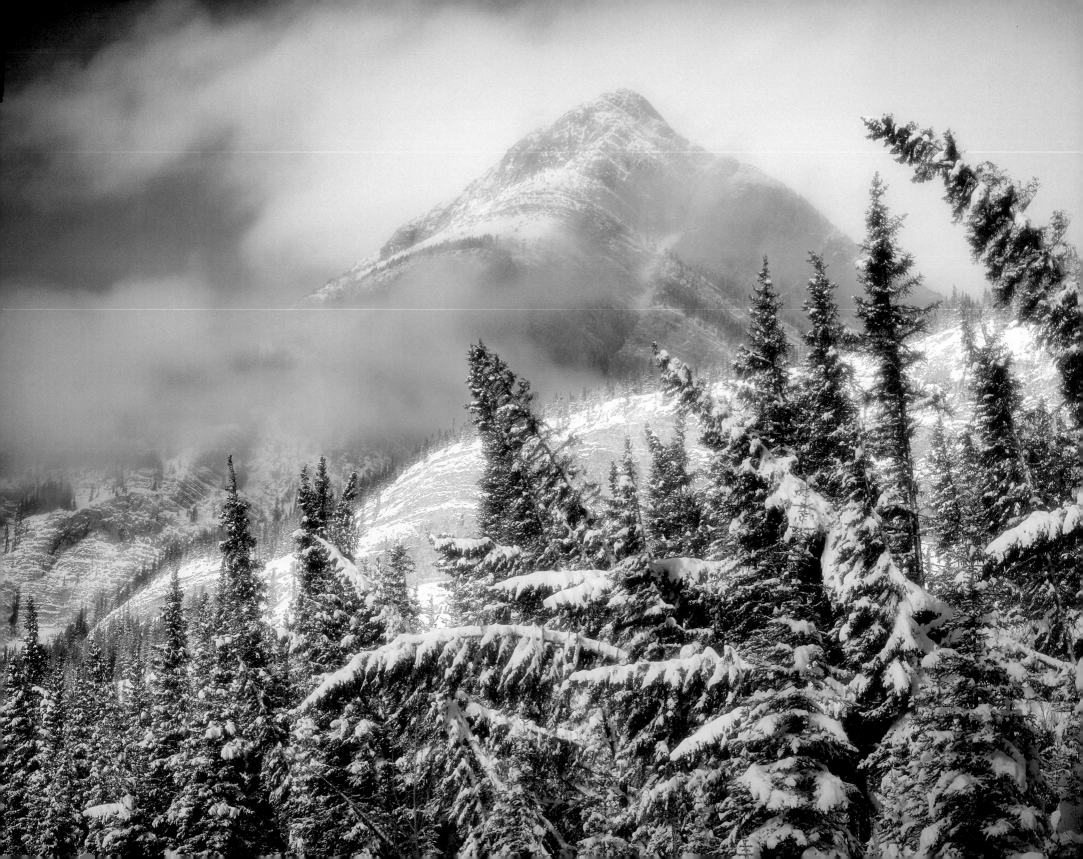

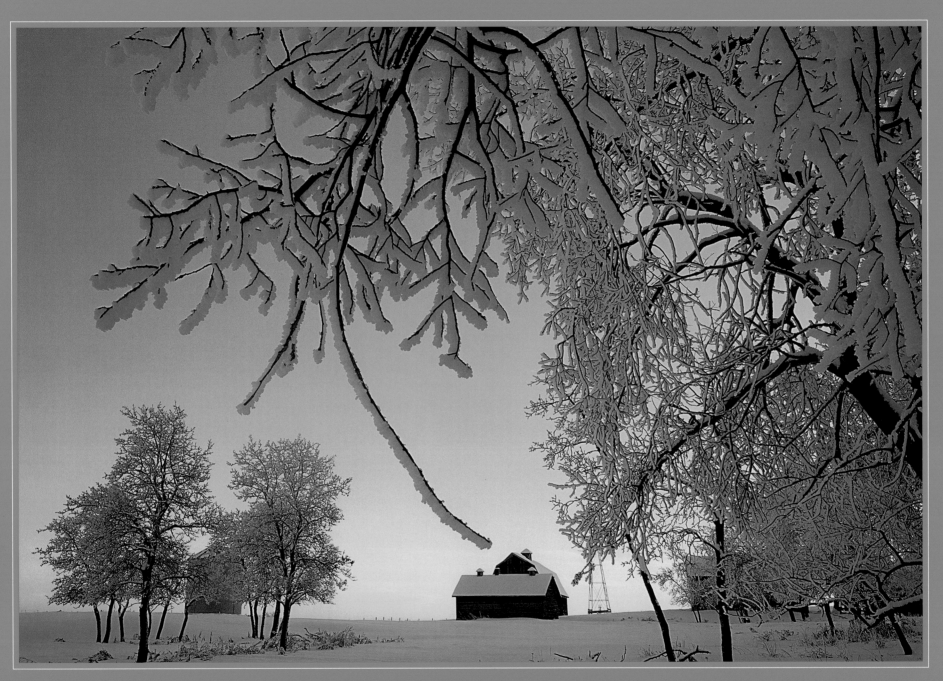

HOAR FROST, NEAR EDMONTON

Light

Light is to photography what gravity is to skydiving, what the Alberta landscape is to this book, what a hike in new wool socks is to toe lint. Light is everything to photography.

How well you understand that, and how well you understand the way film or digital capture sees light, will determine the level of creative control you have over your own photography. The moment you take the leap of understanding to realize that you are not photographing a subject but are photographing light is the moment you begin to have control over the medium. Photography will then slowly start to become a matter of exercising your skill and craft rather than just being a hit or miss shot in the dark.

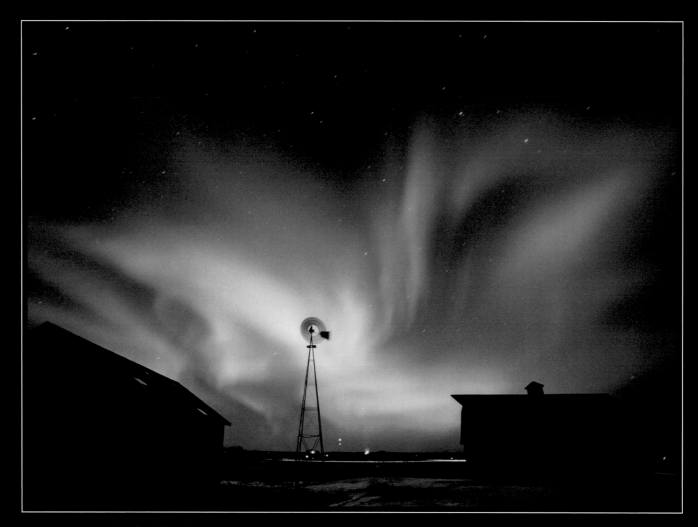

NORTHERN LIGHTS, NEAR EDMONTON

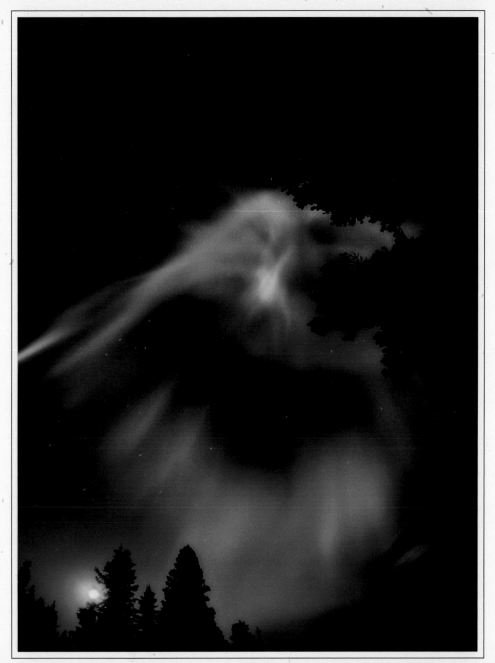

NORTHERN LIGHTS, FULL MOON, SWAN HILLS

Alberta

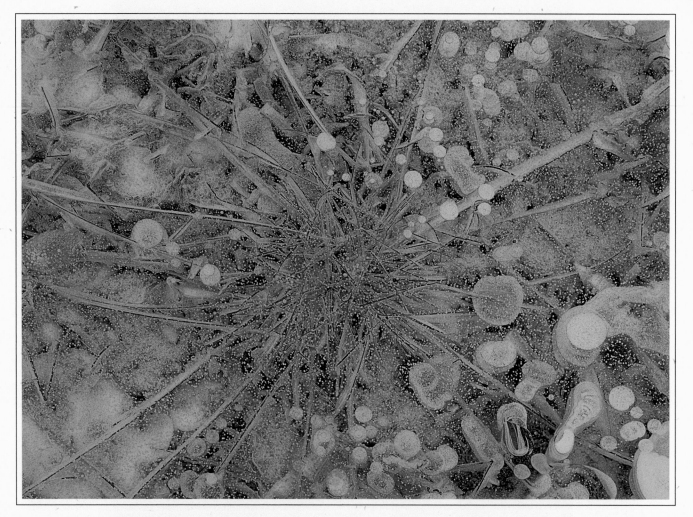

GRASSES FROZEN IN, SHORE OF ABRAHAM LAKE

INTERSECTION SIGN, MINUS 40 DEGREE MORNING, NEAR OLDS ➤

Alberta

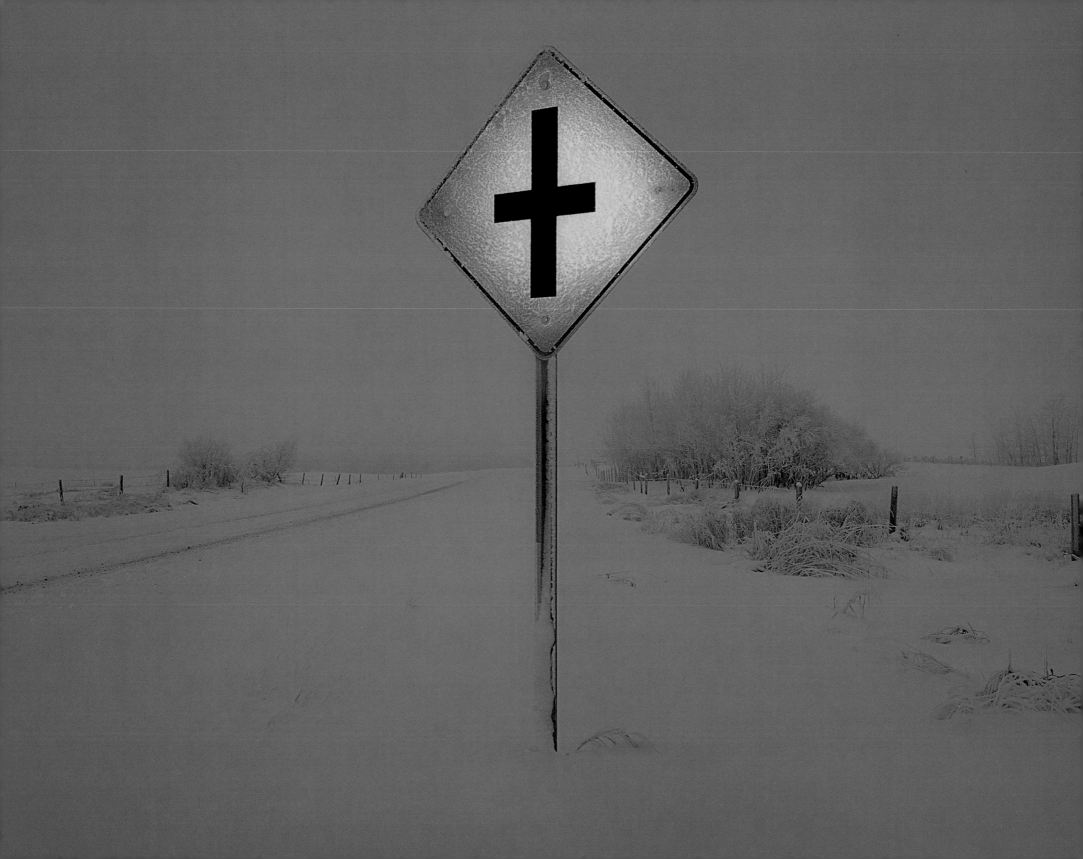

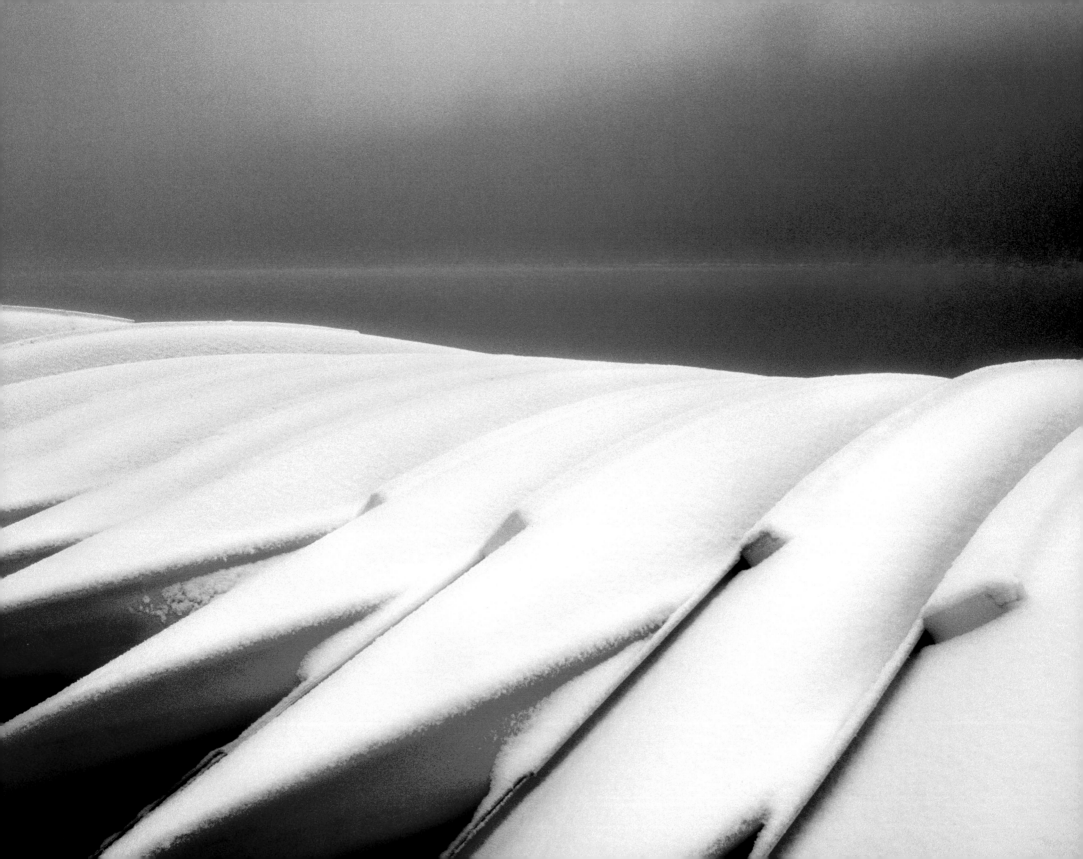

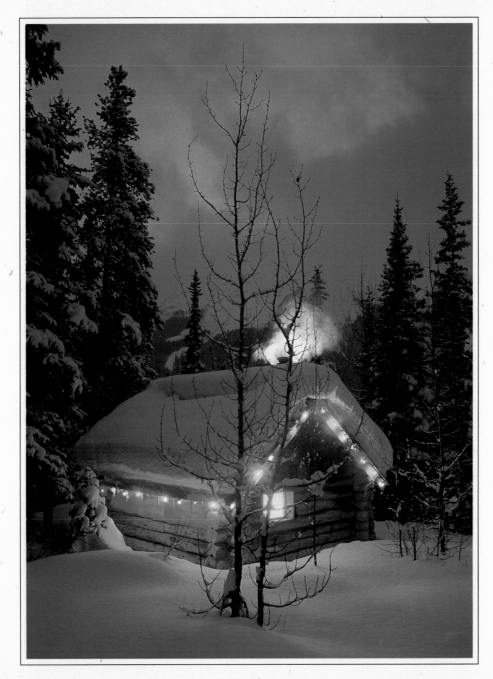

RAMPART CREEK CHRISTMAS,
BANFF NATIONAL PARK

◄ FRESH SNOW ON OVERTURNED
CANOES, SHORE OF LAKE LOUISE,
BANFF NATIONAL PARK

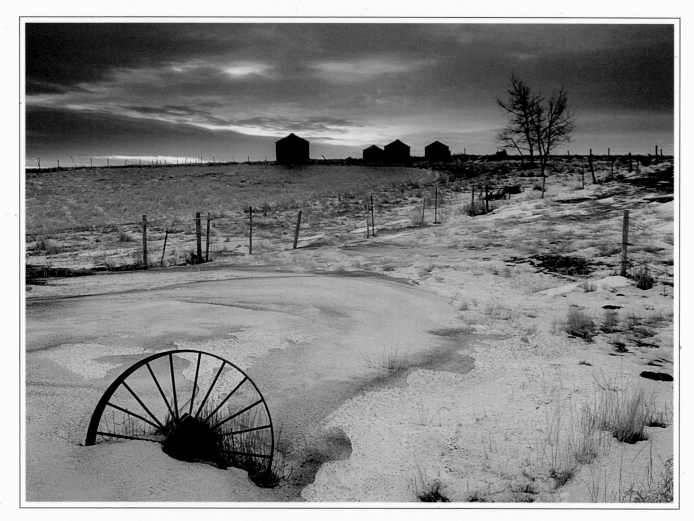

HAND HILLS, CENTRAL ALBERTA

HOAR FROST, NEAR BEAUMONT ➤

Alberta

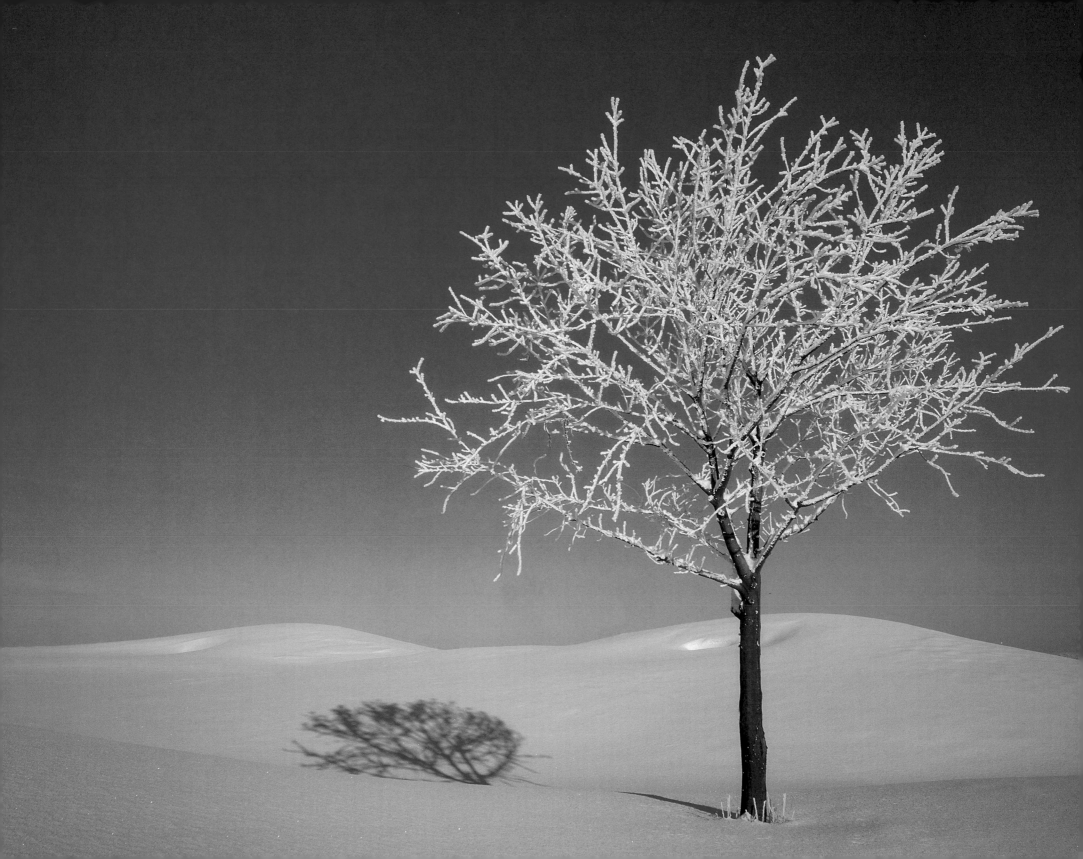

Art

Sometime early in our middle years we begin to understand the concept of mortality. It is at this time in our lives that we start following a stronger desire, whether consciously or not, to create something that will last beyond our own, all too brief, lives and that may stand as an example that we once lived, had ideas and were special in some way.

Once we understand that our time is finite, an incalculable value can be appreciated in every day, hour, and moment of life. This preciousness of time combined with its expenditure in the creation of something is what gives Art value.

Art can be found in many human activities. A baker, a factory worker, an athlete, a boat builder, a sculptor, an electronics engineer, a social worker—all can be engaged in the process of investing their time to create something. The something can be a physical object, a thought, or an impression left on someone else's life, but the point is that it involved the expenditure of someone's time.

Whether this expenditure of time has value is also a function of how it is perceived by others. Much like the concept of a tree falling in the forest does not make a sound unless there is someone to perceive the sound waves, the product of an individual's time cannot be seen as Art unless it is communicated to someone. When I buy a loaf of bread, I have a very practical reason for buying it—I want the loaf that, to me, tastes the best. However, if I meet the baker and am made aware of his or her personal pride in having made these loaves of bread, that the product and profession are things they are proud of, then my personal appreciation of this loaf of bread will undoubtedly increase. I can appreciate the Art of the baker in the loaf of bread.

It is the investment of someone's precious allotment of time, combined with the recognition of that value by another that is my (still evolving) definition of Art.

I would caution against a simple notion of time being just the amount of time it takes to click the shutter of a camera or combine the ingredients to bake a loaf of bread. All the accumulated experience and knowledge that has led up to that particular moment of creation weighs into the measure of its value.

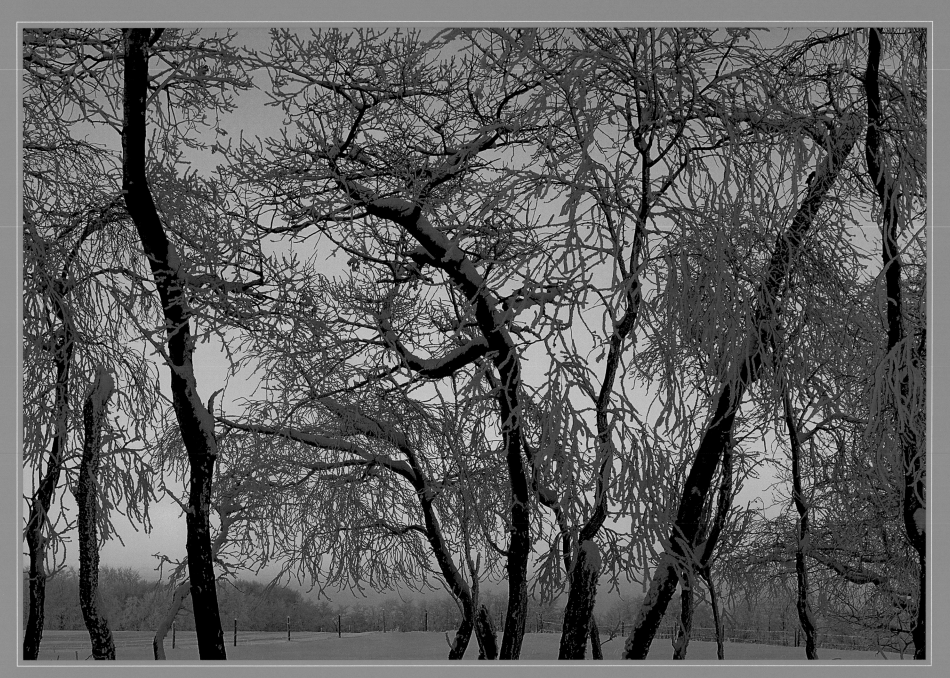

HOAR FROST, DUSK, NEAR EDMONTON

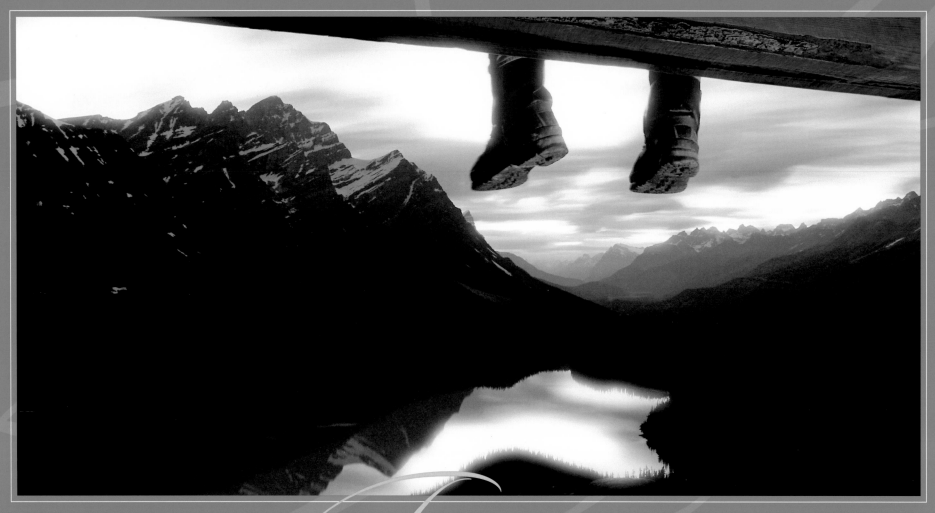

PEYTO LAKE OVERLOOK, BANFF NATIONAL PARK

Thank You

To the people and province of Alberta, and to Canadian Forces veterans for creating a home
where an individual can grow up free to pursue goals, have a future, and dream big.